ADVERTISING PHOTOGRAPHY

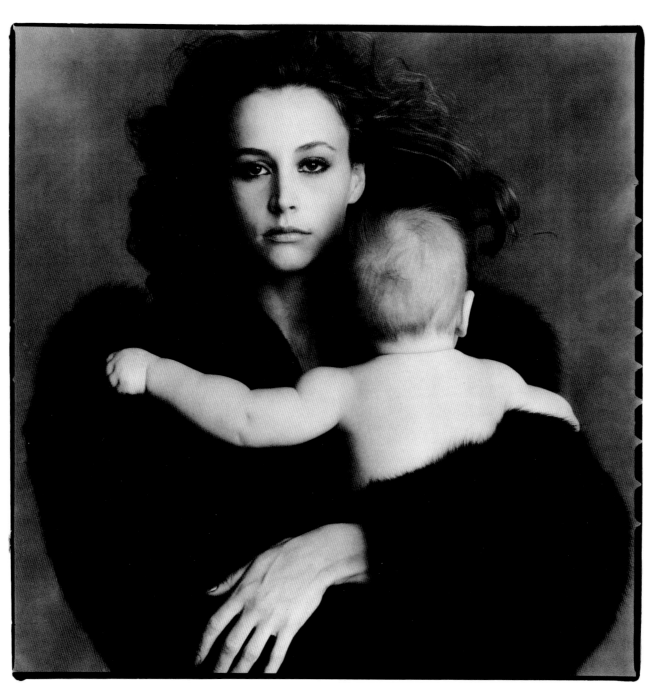

Photograph by Gordon Munro. Model Barbara Langlois, taken as a gift for her child.

ADVERTISING PHOTOGRAPHY

BY ALLYN SALOMON

AMPHOTO BOOKS
American Photographic Book Publishing
An Imprint of Watson-Guptill Publications
New York

To Marilyn, Henry, and Alicja . . .
for enduring a demanding persona

First published 1982 in the United States and Canada by AMPHOTO,
American Photographic Book Publishing,
an imprint of Watson-Guptill Publications,
a division of Billboard Publications, Inc.,
1515 Broadway, New York, N.Y. 10036

Library of Congress Cataloging in Publication Data

Salomon, Allyn.
 Advertising photography.

 1. Photography, Advertising. I. Title.
TR690.4.S254 770 81-22820
ISBN 0-8174-3503-4 AACR2
ISBN 0-8174-3504-2 (pbk)

First published in Great Britain in 1982 by
Thames and Hudson Ltd, London
ISBN 0 500 54081 0

The publishers are grateful to the photographers for permission
to reproduce pictures included in this book. Rights to photographs
remain with individual photographers.

Manufactured in Japan

First Paperback Printing, 1987

2 3 4 5 6 7 8 9 / 93 92 91 90 89 88

ACKNOWLEDGMENTS

Special thanks are due to the photographers for their gifts of time, concern, and beautiful work. I am deeply indebted to Jim Walls as a bottomless source of care and criticism.

The work of my editors, Michael O'Connor and Judith Royer, was unusual in its scope as well as its quality. Their confidence in me made working with each of them a pleasure right through the eleventh hour. I am especially grateful to Brian Mercer, whose creativeness and calmness in the face of competing demands in the design of this book were the perfect conclusion to the support I received from my publishers.

I am grateful to Herb Leavy, without whose initial support this book would not have been written.

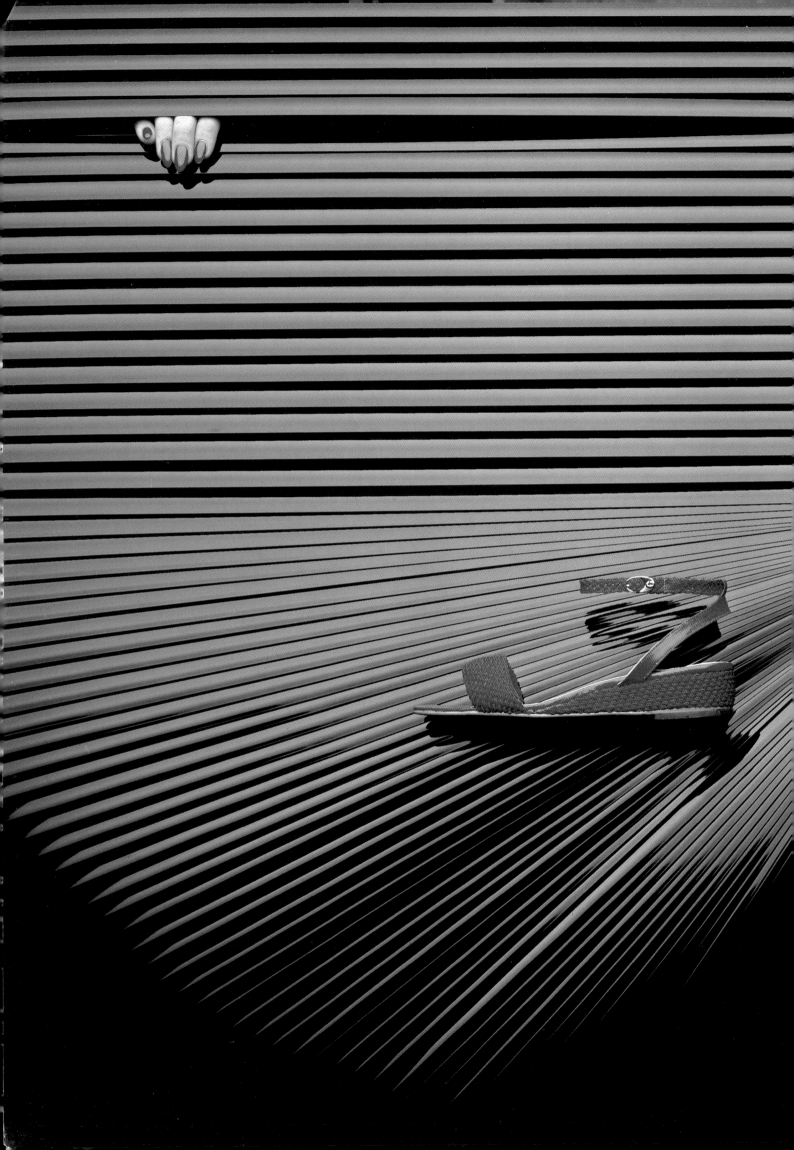

CONTENTS

Photograph by Gary Perweiler. Woman's red shoe, for Gucci.

Photograph by Cheyco Leidmann. Test shot.

INTRODUCTION

The Art of Advertising Photography

Photograph by Jaime Ardiles-Arce. Gloss and geometry in a New York bank.

This book is made up of nine photographers' work. Each is a premium example of quality within a category. Each category in turn is among those current in the vocabulary of art directors, who, in developing visual concepts, must separate the field of photography into categories that they can draw from to produce alternative visual strategies. The categories represented include the following: big-set illustration, still life, fashion, food, annual reports, beauty, interiors, portraits, and settings. A bottle of beer, for example, could be represented as a beautiful still life, in a big-set illustration of people drinking beer and enjoying it, or as a fashion shot. Use these categories to begin to structure your visual abilities, to define your particular tastes. To describe what is beautiful in the world is to describe everything for those who have a vision, a defined aesthetic.

The visual categories in this book are used as a starting point for more selective viewing and establishment of preferences by the general public—leading, it is to be hoped, to a more visually literate dialogue with advertising photography and the environment, in general. Many of the premium photographers included, who have given to this book with great involvement, are breaking out of these same categories by the variety of work they produce, but they are unquestionably prime examples of the category within which I have placed them.

Advertising photography at its best represents something attractive to the public, not because it "manipulates" but because it makes us "visually aware." Most of us take snapshots to show Uncle Ned's big catch, but few of us connect these selections of a part of what we normally see with visual literacy. Advertising tries to present aids, road signs, along the way to this visual sharing. Those photographs that sell a product, a company, a service by direct allusion go unrecognized as independent art products beyond the client's marketing goals. First and foremost these images represent an artist's instincts, his style, wed to the product bottle, piece of shrimp, fashion session, new experience of perfume, or

company image of sobriety. Vision in each expresses the individual impulses of a real human presence.

Each of these visualizers, in satisfying himself, intuitively organizes his visual field in a way that reflects his uniqueness. This has nothing to do with a medium of persuasion, advertising. It is a question of need . . . of necessity bearing response. An artist at the peak of his powers reaches success by generation of what are his sensibilities, projected visually. Beyond technical excellence, he is the sum total of his experience intensified and caught at the moment of the shutter's click. In the elusive process of commercial success, these artists have managed to have a continuity of personal style that has been enriched, not limited and diluted, by varied assignments.

In advertising, those with a style, a vision, are hired as photographers . . . much as the artists of the Renaissance were engaged by the Medicis. They are no longer shooters of layouts but practitioners of a visual tai chi, deftly coordinating subtly modulated fluidities through space and time, using color, hue, line, tint, shadow, and ordering of space. Each is unique in his visual style. Technical expertise is assumed. Delivery is unconsciously flawless.

Both because of the difficulty for most of us of understanding others in their uniqueness by their visual production and because of the constant eddying stream between art and artist, I have tried to give a novelistic evocation of the presence of each of the artists, to give a sense of how his personality is engrained in his work. In each case, then, the transposition is personal, yet general in terms of categories. We can only sense the photographer's presence, see him as familiar, and look at his work to sense if it reflects the character we meet in the accompanying text.

It is these artists' uniquenesses that are woven into the fabric of the product's image as it reaches the intended audience. Marshall McLuhan asserted that "the medium is the message." One might go so far as to assume that the buyer's interest is less in response to

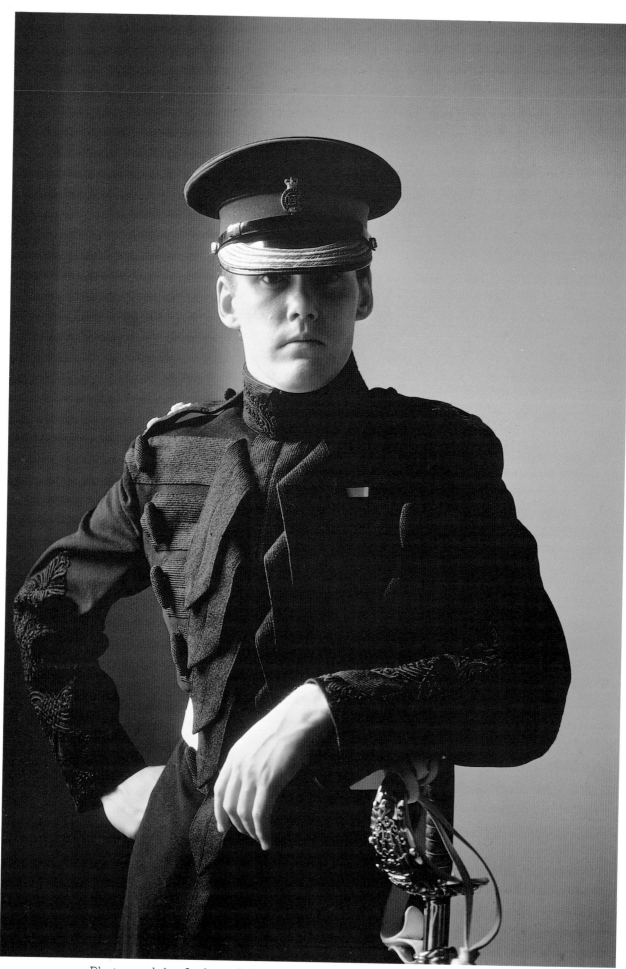

Photograph by Anthony Edgeworth. Guards officer in London, from his book
The Guards (New York: Crown, 1981).

the product than to the visual experience. In a sense, it could be argued that the advertisement is a ritual visual experience that touches its audience by using at the same time a visually literate vocabulary and a personally expressive one. Advertising often overlooks this soothing, healing aspect of its work and the advertisements offend the public's sensibilities by hard sell and lack of aesthetic consideration . . . thereby skipping the personal, touching experience of art.

Advertising photography has been characterized as "slick" in contrast to photography that is "art." In fact, the sheer magic which occurs when it affects its audience is high art as were the Medieval Mystery plays. Both show a vision that is meant to move the masses. Advertising photography that is well done is visual ritual, enacted by the supporting unique visions of each of these photographers. With each photographer presented here, the visuals have the dross squeezed out and left behind, with only the expressiveness and energy of aesthetic effect remaining.

These aesthetic effects are guided in each photographer's process of creation by strongly contrasting personal values. To Burt Glinn, a photograph is valid if it is discovered in the everyday world of real people involved in unposed real activities. Out of this he pulls an image that is visually graphic and makes a point in a photojournalistic sense.

Reid Miles adds layer upon layer of revealing detail to mimic a time and place and brings it to life with actors caricaturing various emotions to create a narrative situation that is alive with overemphasis to the point of jumping off the photograph, as if we were watching a scene in the movies. This reality is, while invented and not discovered as with Burt Glinn, rich in meaning as a mimesis, a mimicking of reality, in a novelistic way, much like a Charles Dickens story might read.

At Gary Perweiler's studio, the effort to photograph functions as a relief valve to siphon off all the nonessentials encumbering an

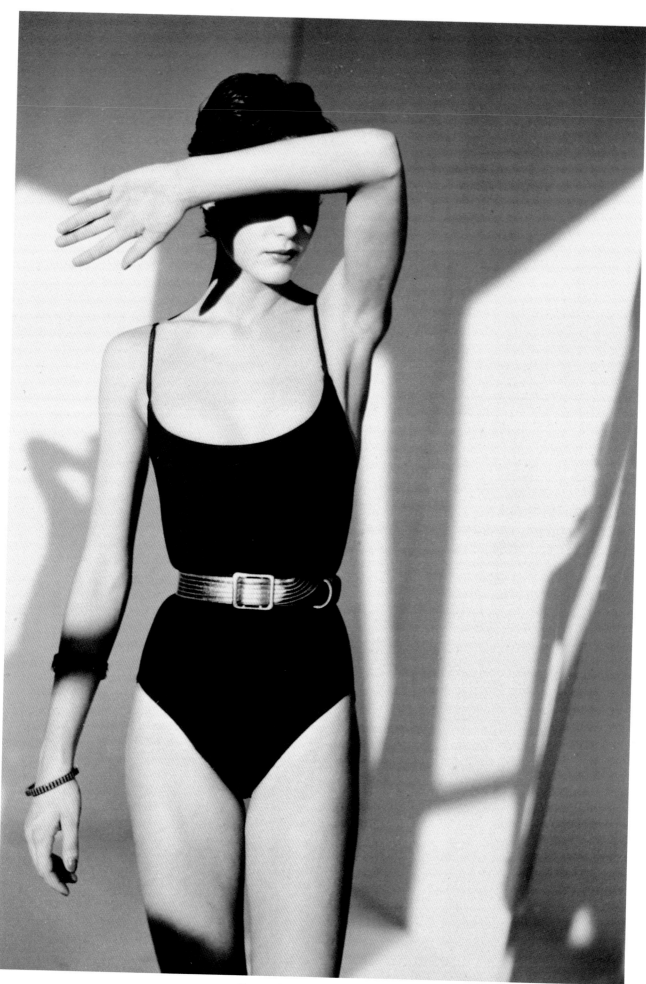

Esme, for American *Vogue*.

object, leaving just enough visual data to read what the object is visually and to see it in a new way without any illustrative layering of meaning. Even the photographic medium serves to eliminate the tactility of, say, paint. He is a true minimalist. He stays clear of the real world that is grabbed on the run by Burt Glinn.

Tony Edgeworth needs to feel that he makes real contact with his subjects. Each participant in the photographic session must interact with others before the photograph that is taken can have meaning. A real presence comes across in the picture as a result of this careful attention.

Arthur Elgort can't resist going after this same sense of reality in his photographs. He starts to shoot photographs the minute he walks into the room and long after he leaves. Everything and anything is fair game for his photojournalistic eye. All of what occurs reflects the world in which he circulates. Those photographed are seen as team members, what goes on as the subject, and the before, during, and after of a shoot as of equal importance. The actual shoot for an ad or an editorial spread is one among many photographic documents of the real situation of the fashion world as a whole that is chosen or could be chosen by Elgort to be used.

For Jaime Ardiles-Arce, his architectural spaces, to be real, must draw attention to the investment of human emotion that they embody. The creation of various interior designers, they have been textured by the attentions of their inhabitants. Photographing this might involve adding details of light, setting off the basic color scheme with an enormous vase of flowers in a complementary color, balancing outside light with inside illumination to emphasize both equally when the designer has made one wall of glass with the intention of bringing in the outside. He glamorizes interior space as well as exteriors as an ode to a reality based on beauty and the celebration of taste.

Gordon Munro's goal is, simply put, to beautify the women's faces that he photographs. Even if the shot is a full figure, it is shot as a beauty shot. One notices first and foremost the subject's face, and the rest is posed around it. The lighting, makeup, hairstyling, and clothing must coalesce under his direction to create a beauty shot that takes best advantage of the features of the model's face.

Arthur Beck defines his goal as one of making the food as appetizing as possible . . . based on his taste. For food to be most real means that it appears at its appetizing best. This does not mean that the food is rendered or indicated in visual form as there before the camera. It must by color, line, form, propping, and quality of light evoke a strong emotional response akin to that which one would have seeing the food at the dinner table.

Finally, we come to the work of Cheyco Leidmann. I have created a new category called settings. Strong color and graphics and more conceptual imagery are its trademarks. Powerful graphics emphasize the reality of the product, while the people are symbolic. They, along with the setting in which they are placed, provide a unique look for the product they surround.

In closing, to those soon to be practicing advertising photography professionally, this book will be an uncluttered window on quality to inspire rivaling visions. The categories offer choices in gearing initial portfolios to commercially viable categories. These choice examples aid discernment with greater visual intelligence. Certainly, knowing some of the work of the best artists in the field whets the appetite to see and judge critically the achievements of your peers. Also, one feels the satisfaction of a certain historical awareness. A very important part of the business is respecting your own professionalism and talent during the initial hard times. Shoot to eat, but don't lose sight of the need always to heed the development of your style. This is the key to creative survival.

Allyn Salomon

BIG-SET ILLUSTRATION
Reid Miles

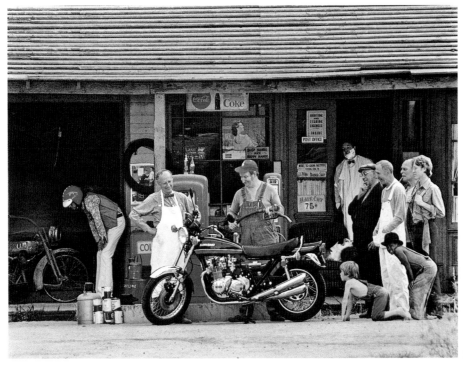

Gas station, for Kawasaki.

A piece of a small town occupies one wall of the studio. The lights are in place, illuminating the set, centered on one of a dozen actors. The director calls from him a great performance. The cameras roll. Or rather, they click. For out of this production, as complex as a take from a Hollywood epic, will come one perfect still. It will be seen not in theaters but in magazines.

Reid Miles is the director. He is also the cameraman—or more precisely, the photographer. Within photography, he has come to be identified as the quintessential big-set illustrator. His illustrations are dramas, slices of life, frozen in the act. They are also life as it looks when posed, arranged to show its graphic essence. As Reid Miles has expressed it: "Design is everything. What I really am is an art director."

He was born in Chicago on July 4, two years before the crash. He was a child of the Great Depression.

"Children were raised differently then. The work ethic was alive in a way that has since vanished. You had to work even if you didn't need the money. You were expected to achieve something. You couldn't be lollygagging around."

His father was a candymaker. Compared with others, his family was fairly well off. That was because: "Well, my father invented the jellybean. That was once my claim to fame."

But his parents separated, and he moved with his mother to Long Beach, California. He remembers a life of hard work, of making work his life.

"There was something odd about hard times, a certain charm. People were more human with each other."

His photographs today reflect his admiration for that pre-television society, his idealization of it. Of a time when people

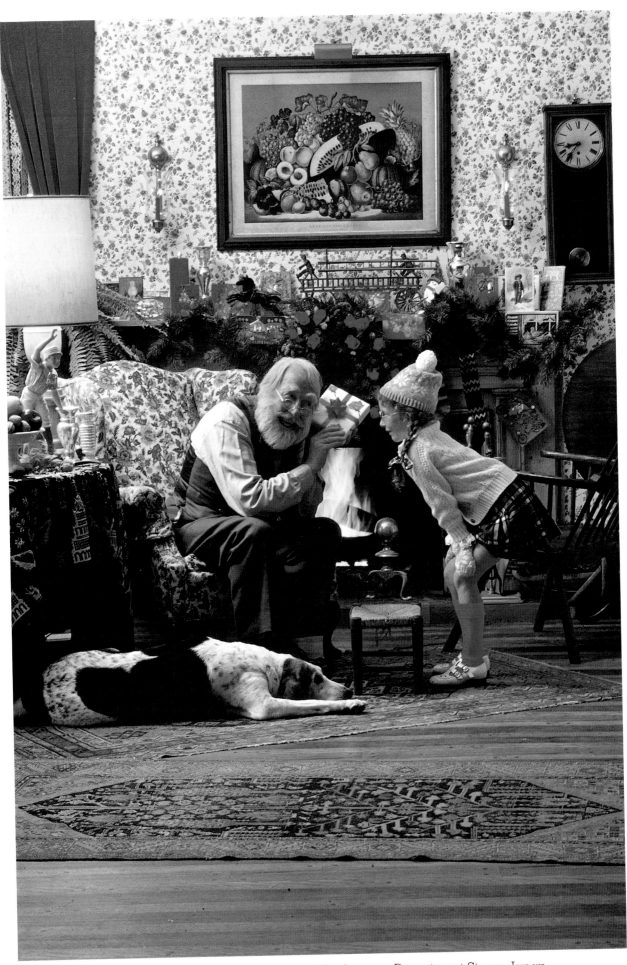

Christmas Eve fireside scene, for Takashimaya Department Stores, Japan.

worked hard, respected one another, occupied points connected by human interchange. A network in which everyone was needed.

"Working people, the middle class, the billionaires in Beverly Hills—I thought of the world as needing all of them. I didn't begrudge the presence of the billionaires."

His sense of people would come back to him later in life and shift his photography away from a concentration on pure design to something expressing "charm and romance." To find that in a world of practical realities. Reid Miles says that his father taught him the need to link creativity with a practical purpose.

"If you can lift what you do to a level of art, to such a pinnacle, and it's something done in connection with advertising—well, it serves a double purpose. It is art and it promotes a product. It's great to think that you might do art that has its impact in the practical world."

Coming out of the Navy at the end of World War II, Reid Miles enrolled in the Chouenyard Art Institute in Los Angeles. After two years he moved to New York, to a brief stint as a fashion model, to a job as a paste-up artist at *Esquire* magazine. Seven months later he was an art director, a career he pursued for the next nineteen years. Reid Miles is one photographer who knows exactly how art directors think. It is knowledge that helps him to do what he wants. All he needs is a hint.

"They don't have to give me a full layout. A few lines telling me what it's all about—that's all I need. I design the sets in front of the lens. I dress them as I go—and worry about people and wardrobes and all the rest of it."

Accountant, for Ciba Pharmaceutical.

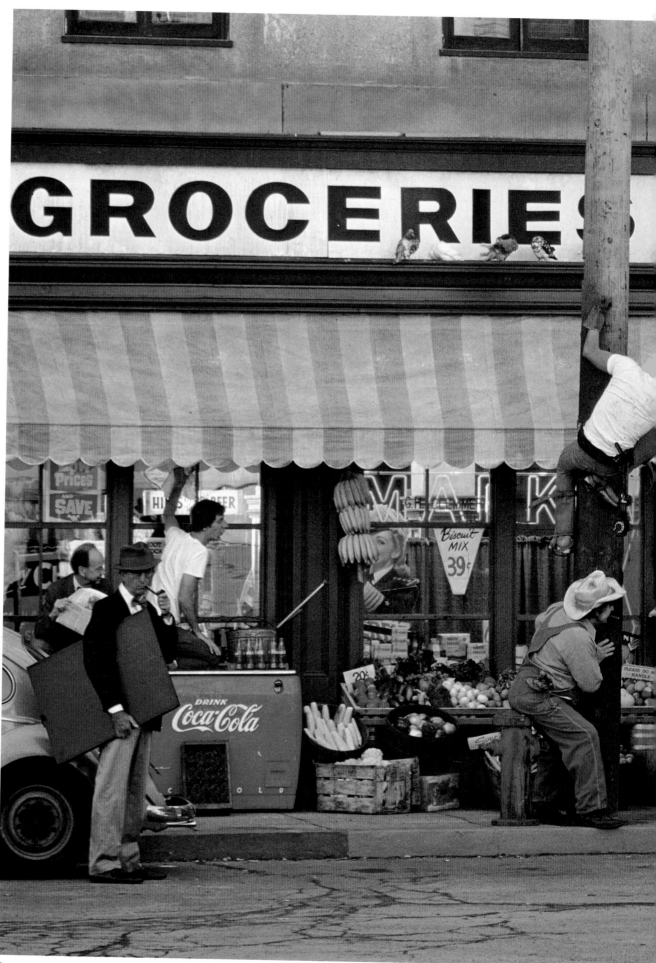

Bus stop, for Greyhound Corporation.

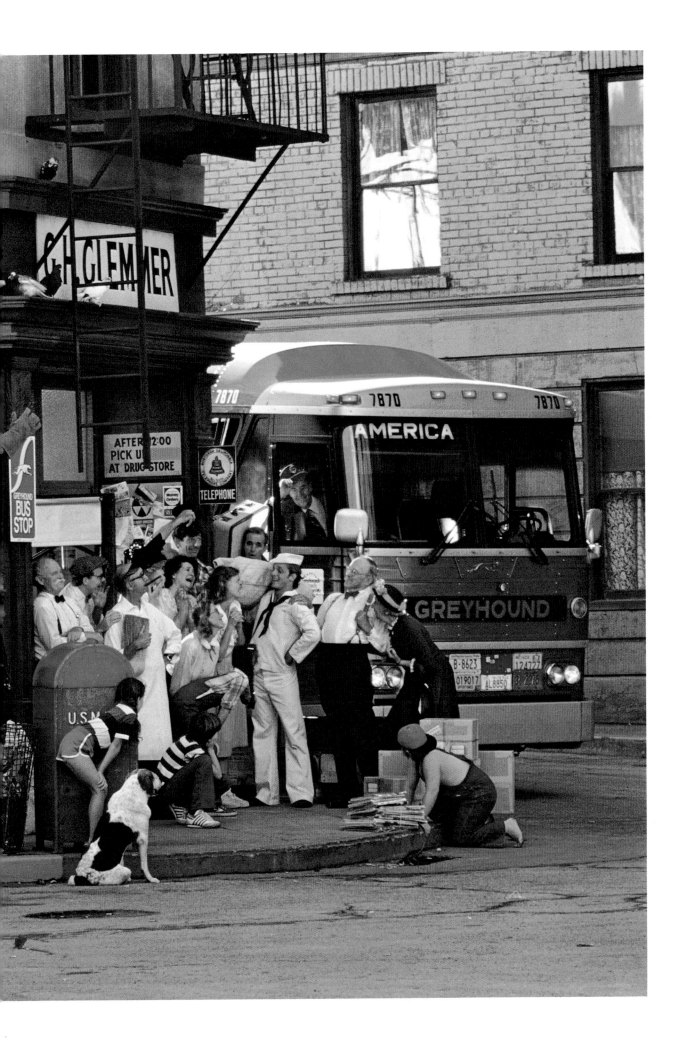

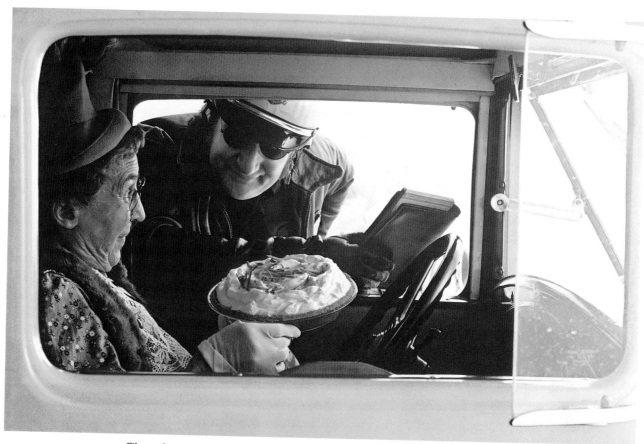

Chocolate cream pie, for "Home" magazine of Los Angeles *Times*.

Coffee cake, for "Home" magazine of Los Angeles *Times*.

expressing a sense of life's certainties. The center of that time and place was occupied by people rather than their objects. The great illustrators displayed these people in all their unique individuality.

But this is exactly what Reid Miles has recaptured with his camera. The scenes he produces freeze the essence of a kind of American nostalgia. How does he do it? He says that a good photographer must be a good storyteller. How precisely does he create his impact?

First is the question of casting. Accompanying the change in Reid Miles's style was his discovery—or his recalling—that Hollywood was full of character actors. He could replace the typical models used in advertising with people who told a story with their faces alone. He found himself working again and again with the same faces. They had become his repertory company.

"They are all actors. And yet they are real people with real faces who know how to turn on in front of a camera. You can get a lot out of them."

He picks them for one of his scenes: "for the roles they are going to play. And yet, being actors, they can play any role. They are interchangeable, whether they are fat or thin, tall or short, beautiful or ugly."

They fall into their different roles—store clerk, bus driver, mom and pop, the classic couple. Once the scene is set and the actors all in place, Reid Miles shoots it in twenty minutes.

"I push them around and get them to peak, peak, peak, get them to do things beyond their normal capabilities. I push them into situations where they have to force their bodies, their ex-

pressions, to reach that peak, and wham! it's all done, and they are totally drained. After that, they fade."

Reid Miles is drained, too. He, too, reaches a peak while the shooting is going on. Afterward, he collapses on a sofa.

"One of the reasons for using the same people is that they learn to relate to each other—and to me. It's a great help to know what they are capable of, to know what I can expect of them. The photograph is based on a relationship. Other photographers don't get the same body language out of them."

His directorial abilities, his sensitivity to actors, reflect something else he has done in his life. He spent two years studying acting with Lee Strasberg at the famed Actors Studio.

"If I had only been younger, and if I weren't already making so much money, I might have become an actor. Still, I learned a lot there. I learned how an actor gets his energy together, how he builds a scene."

And his big-set stills become instant movies. Yet the technique is different from the movies.

"In a photographic print, the acting is exaggerated. The picture looks totally dead until I start yelling. Exaggeration looks stupid in the movies, but with a print, you have to exaggerate or it doesn't move. I portray the extremes. What I produce is a comic strip."

But then, he was raised on the comic strips—on the Katzenjammer Kids, on Maggie and Jiggs. You could stretch a point and say that the comic strips present a 35mm view of life.

Reid Miles has stayed with the 35mm for its ability to catch the spontaneous moment. He uses powerful strobes, set on low

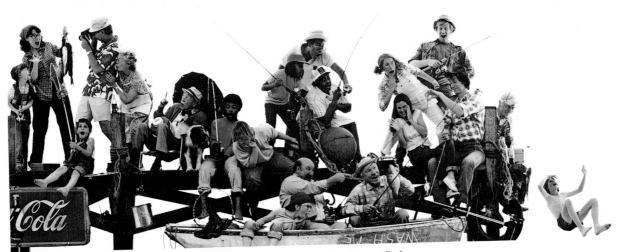

Gone fishing, for Coca-Cola.

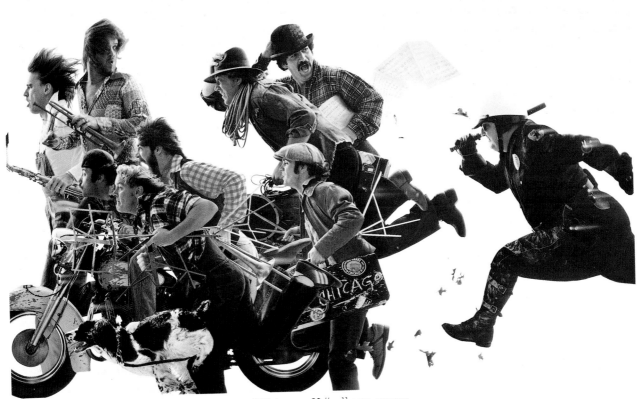

"Chicago X," album cover.

wattage to recycle quickly. His small camera is an insect buzzing around his giant set. He shoots quickly as his performers reach their peak, catching that certain moment that will never be repeated.

Casting is one problem. Another is the set.

"You do the set for its energy and emotion. My pictures are hammered together in the studio, and I want sets built to full scale. In the studio, I have absolute control of the lighting. I finish designing the set in front of the lens. I add layer on layer of dressing and texture."

He uses a slightly long lens, usually 105mm, to flatten the perspective and make the picture more of an illustration. Flattening is echoed in the way all the picture's elements are positioned along flat planes layered one on top of another. Reid Miles elaborates his sets the way an illustrator would, putting in elements, taking them out, as if he were an art director working on a layout.

"I try to get something legible. Easily read. Almost like a shadow picture."

He doesn't mean that legibility is to be found in pure design, any more than life falls into arrangements of pure design.

"I like to add junk to the picture. Anything to intensify the moment of the story, to build it, aim it at that moment. Shapes and textures are overwhelmingly interesting."

Here he shows himself as the master of revealing detail. And all assembled on the instant.

"I can build the biggest, most complicated set, dressed and ready to go, in seven hours, be all done by four-thirty in the afternoon."

Yet he didn't mention the planning that precedes this construction. The large staff that builds and lights these sets—under Reid Miles's direction, of course—also researches the props and wardrobes from Hollywood's rich resources, even finding the appropriate back lot when needed for the bigger scenes, such as his Greyhound ads, which include over a hundred people.

And he is the director, elaborating a full drama out of a few lines emanating from a client. It's the concept that holds him. He doesn't want to get trapped in the mechanics of it.

"The camera is just the means I use to do what I do. Lenses, strobes, the things we use every day—my assistants know all about them. I'm not interested in photography as such. I don't want to get interested in it. All that technical stuff gets in my way. All I have to know is what it can do."

Yet he doesn't know everything it can do. Reid Miles is moving in new directions, toward something different from big-set illustration. He is testing, trying new things, reaching for pictures as brazen as a comic strip. He takes 8 × 10 Polaroids of the elements of his picture. He puts them together like a collage and retouches the composite so that it looks like one scene. The effect is controlled—and striking.

"We're in the business to be creative. I have to be satisfied with the quality of the work, and amused and excited at the same time. That's what life is all about."

In the business. And creative. That is where advertising is lifted into art.

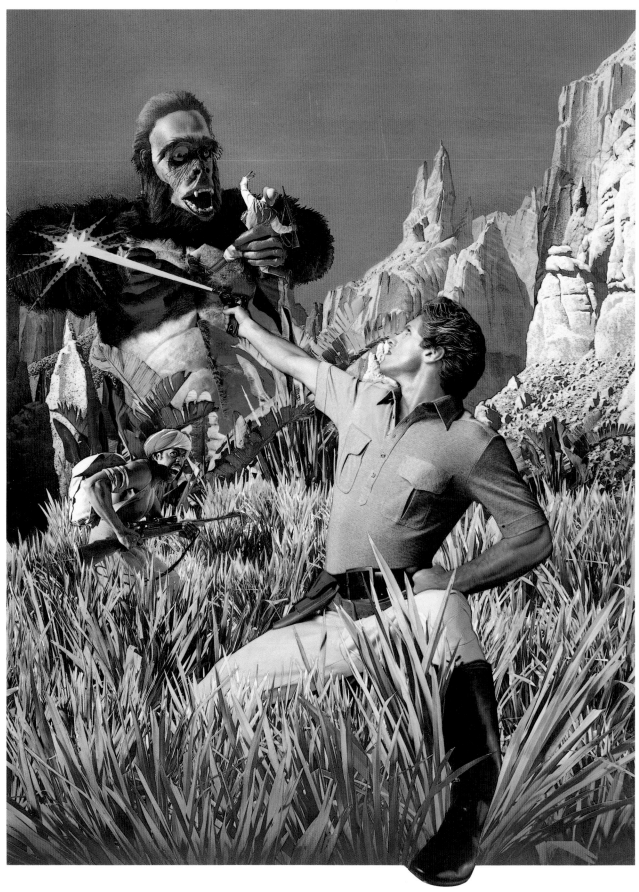

Jungle Jim, for Joel Shirts.

FOOD

Arthur Beck

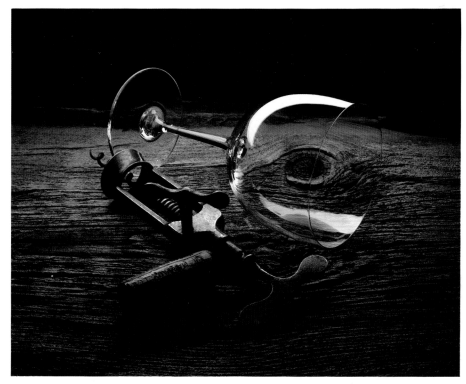

Wine glass and corkscrew, sample shot.

His strawberries gleam with perfect highlights, as if painted by a Flemish master. His cheese glows, throwing warm shadows behind the knife that has just cut into it. The head of a fish, a cascade of silver, glitters wide-eyed, half smiling, on a bed of ice. This is the food of dreams. An Arthur Beck portrayal of an ice cream cone has sent quiet householders running for the corner store. He himself sometimes sounds surprised that he is making such portrayals.

"When I was first getting started as a professional photographer, I never figured I would get involved with food. I thought food was too difficult."

It is difficult—there is no doubt about that. Ice cream instantly begins to melt in the open air. Soufflés sigh and start to fall. Arthur Beck stands behind his Deardorf waiting for a soufflé to be run out of the kitchen.

"A soufflé is the test of a good food photographer. Good shooting of a soufflé—well, you're talking about a total of forty-five seconds. In that time, if you're lucky, you can get eight to ten sheets off it."

With food, speed is one key to success, and Arthur Beck works very rapidly. What else is needed?

"Lighting is very important—perhaps the single most important element. I've always believed in a single light source. Occasionally I'll use a slave with a strobe, but not so you would notice it, not so it throws its own shadow. Just to fill in a bit."

This is studio work. Arthur Beck's studio is located in a loft building in New York's Chelsea district. Walking down the dark street in the shadow of the Flatiron Building, you would never guess that inside there three eggs and four link sausages have been fried to look more beautiful than any breakfast ever before

34

seen. Looking for contrast, Arthur Beck has placed them in a battered pan. In the ground glass of his view camera, the egg yolks shine like liquid gold.

On the high walls of his studio, his pictures appear from floor to ceiling, reminders of a hundred ad campaigns, "and not a thousandth of the work I have done," he says. Arthur Beck has come a long way from the poor neighborhood in Newark, New Jersey, in which he was raised. No one ever worked harder than he did to get where he is.

"As a kid I liked to draw—and I could draw very well. I mean my drawings were always meticulously done. But I was frustrated because I could never capture what I was drawing. I would try a portrait. People would look at it and say it was beautiful. But they would never recognize the person in it."

Drawing led him to art school, a small art school in Newark where he could study advertising design. He was thinking of becoming an art director.

"In your second year, you had to take photography as part of the advertising design course. That's where it hit me. I liked it so much that I put all my electives in photography."

That meant three full days a week as a student photographer, including work in the school's small darkroom. A job as a cashier in a clothing store paid his upkeep. He was working seven days a week, twelve hours on Saturday, getting by on four to six hours' sleep a night. What kept Arthur Beck going was that he had found an art form that captured perfectly what he was trying to get.

After completing his course, he pounded the pavement in New York City looking for a job. When he was down to his last cent, he was taken on as a printer by two photographers who shared

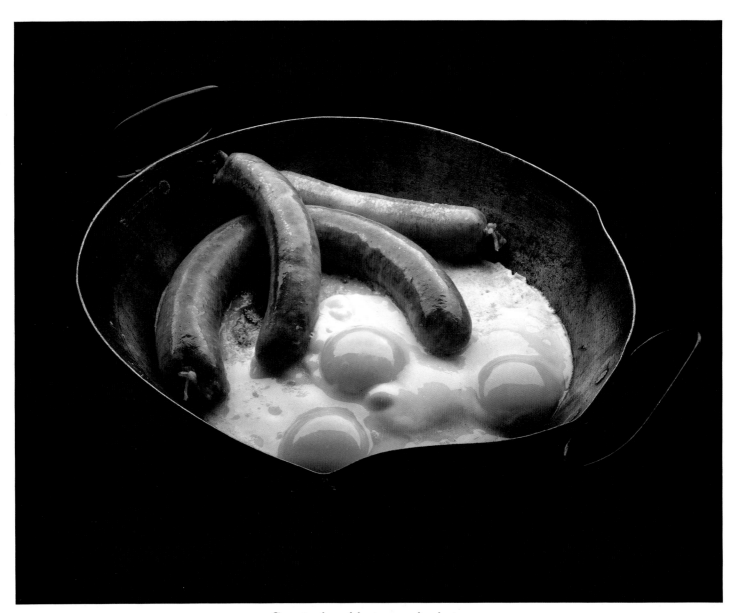

Country breakfast, sample shot.

a studio. One of them worked in 35mm, the other in large format. It was a situation in which he could learn how to be a professional. He stayed there for nineteen months even though he was being paid about half the going rate.

"They let me shoot in the studio on my own. I was there every night. Even on weekends. I would set up a still life, a glass of beer, something like that. I would shoot it. One 8 × 10 transparency. Then I would take the set down. When I saw the transparency, I would see what I wanted to change. I would set it all up again, put the light where I thought it should go, and shoot it again, one transparency per setup. I went on doing that for months."

Who paid for all those one-at-a-time transparencies? One of the two photographers was crazy about playing darts. But his darkroom assistant always beat him.

"I was one hell of a dart player. We kept a running account of my winnings, and I used to take it out in film and processing."

So one of the two partners supported his experiments with a view camera. Dick Jeffrey and Mort Schreiber . . . Beck looks back fondly on both of them. He credits Schreiber with giving him his final polish as a printer. He got so good in the darkroom that he went looking for a job with Richard Avedon.

"Avedon was always known for having the best printer around. He needed someone because his printer had just left him. I went over there looking for $175 a week and turned down an offer of $300. This was because I would have had to work for two people again and I didn't want that any more. It keeps you too busy."

What followed were the years of trying to set up on his own. It was a time when he was putting all his profits into equipment. He was shooting still life. He had tried other things.

"At first I was thinking about beauty or fashion. Back in the studio with Jeffrey and Schreiber I tried working with models. I found I had a lot of problems with them. The worst part of it was that I had to depend on someone else. I found out that I could do still life all by myself."

Working on his own he quickly achieved a quality capable of attracting the services of photographers' representatives. In one short period, fourteen of them passed through his studio, and twelve of them wanted to represent him. All of a sudden, as he says, "my work caught on." He now has a rep who finds it a full-time task to work just for him.

"Still life is where you learn how to use lights. It is the area, too, in which you develop the best sense of composition and design. There aren't many fashion photographers who can do good still life. But a great still-life photographer can shoot anything."

Arthur Beck does shoot anything, as the pictures on his studio walls proclaim. Among the still lifes are many other kinds of pictures—portraits, fashion, beauty. Also included are tear-sheets from the Marlboro campaign. This is one of several campaigns that have taken Arthur Beck out of his studio. Marlboro sent him to Montana and Wyoming, to Texas and Oklahoma, to shoot cowboys on mountains and plains under natural light.

Food, however, remains his mainstay. What Arthur Beck thinks about is the perfect lighting for a bowlful of eggs. He takes the ultimate in Eggs Benedict and places it lovingly on top of the cartons the eggs came in. The rough-textured grays of the cartons provide a jagged landscape for a golden waterfall of Hollandaise sauce.

"Any good still-life photographer will eventually go into food.

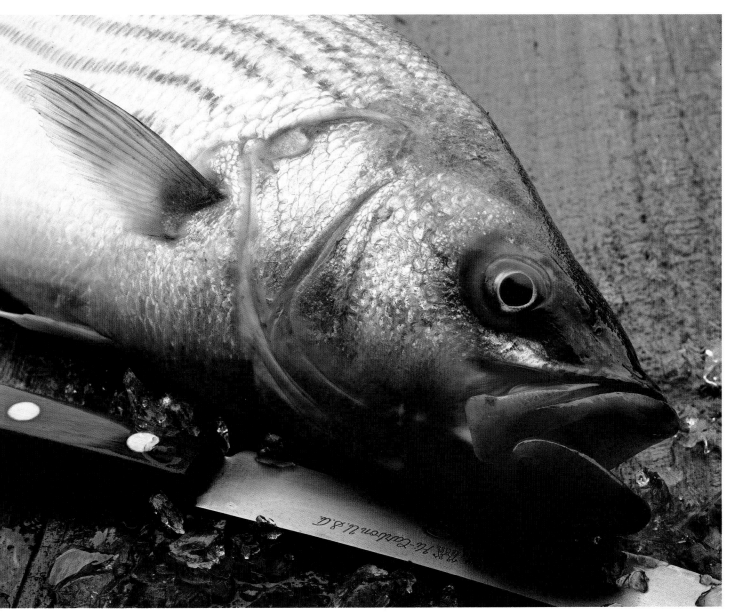

Fish, sample shot.

California quince, sample shot.

That's where the business is—and therefore the money. Opportunities are limited to do still life with hard goods."

The food campaigns are there, too, blazing from the studio walls—Sunkist, Hellmann's, Seagram's, General Foods, 7-Up, Puerto Rican Rums, Wishbone salad dressings, California avocados. Arthur Beck has worked for some of these clients for years. The pictures are as familiar as the inside of your living room. You have seen them in many magazines . . . in *McCall's*, *Bon Appétit*, *Good Housekeeping*, *Ladies' Home Journal*.

Sometimes he has contributed more than his pictures to a campaign. For Puerto Rican Rums he came up with an idea. Why not a rum martini for women? Something more benign than those made with gin or vodka. Rum is a tropical drink, and this was a way of selling rum in the winter.

The food is taken with a Deardorf, with its interchangeable lenses, its tilt front and back. The proper lens is preselected. The lighting is all in place. The perfect exposure has been predetermined, tested on Polaroid sheets. It takes a while to get set up. The food is rushed from the kitchen. The shooting is over before it has barely begun.

Arthur Beck shoots black-and-white Polaroid for exposure. He can tell whether the color will be correct because the Polaroid has the same speed as the color film. Although, as he says, you can go a half-stop darker with the color film. The Polaroid is just that much off.

"I take five sheets with two right on the button. The others are bracketed, but only a quarter of a stop. You've got to give your art director a choice. On the other hand, I don't want to give out two or more transparencies that are off by a larger bracketing. That's just a waste of time and money."

41

And the lighting, as he says, is the heart of it. "A soufflé might show up soft in certain lighting whereas a chicken pot pie would look totally different. You might need a hard light on it and really get it in there. If it's liquor, wine, or beer, I might be able to light it three different ways and they would all look good. They would all be correct. Sometimes it depends on how you feel that day."

Still, in principle, he usually wants to stick with one main light—the way nature itself provides one main light.

"One light should be strong enough to make the object look good without having to place all sorts of lights in addition. With that main light, I might add another, but bounced off a card or reflector, so that you're not really aware of it as a separate light. To me it's wrong to have three different highlights showing.

"I might use two or three lights on people because it cleans up their complexions. Women love that. Of course, if I do it, I will make the three lights look like one."

Sometimes the one source will be a bank of lights. Largely self-trained as he is, Arthur Beck reinvented the bank of lights. It took him some time to realize, still on his own, that a bank of lights could be made movable.

"The creators of bank lighting were not O'Neil or Marco—or Beck. The original creators were Sokolsky, Mike Cuesta, maybe a couple of others. They made a big source of lights that could be moved around. That's what I did. I did it on my own, not even knowing that anyone else had ever done it. I would take seven to ten strobes and frame them off all together.

"You either use the bank or it uses you. You have to be the master of the bank. You can't control it by changing it all the time. But you can control it by using reflectors, or cutting it off

Part of a menu cover.

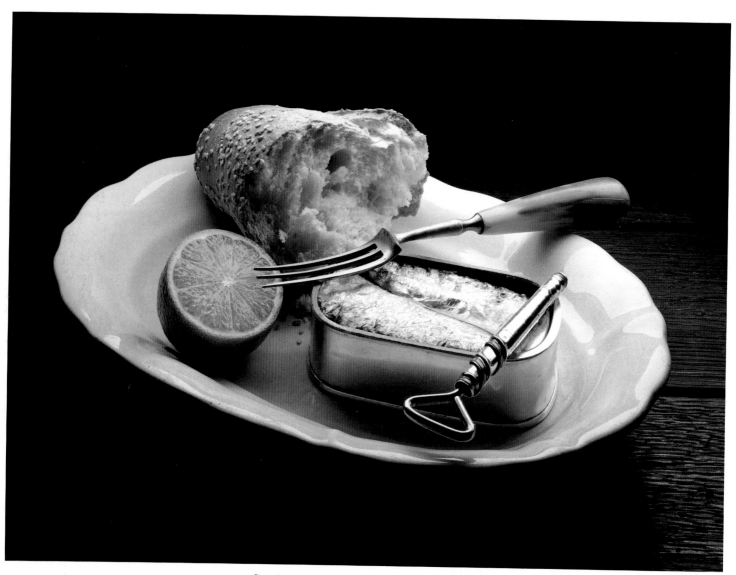

Sardines, bread, and lime, sample shot.

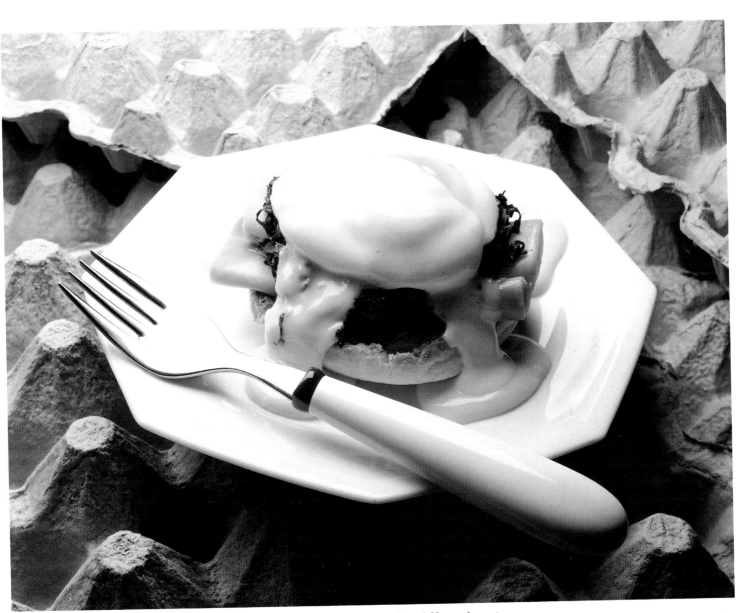

Eggs Benedict, editorial for *Good Housekeeping*.

with a shim or a gobo. Incidentally, I hate the words we've created. I like 'feathered.' I brought 'feathered' over from golf. It means to hit higher and softer. To make it drop down. You do it very lightly as opposed to smashing it."

Then there is the kitchen in which the food is prepared under the supervision of a top home economist. The cooks and food stylists are clad in white, moving briskly in spotless surroundings as if they were at work in a hospital. With its four oversized ovens, its stoves and refrigerators, its deep-freeze units, the kitchen is big enough to service a hotel. The food that comes out of it is honest food. No food ever looked better. And yet it is not for human consumption.

Arthur Beck will show you that it is real food. He wants it to be honest—as honest as his lighting. He will throw shadows but you won't notice them. They are soft shadows, producing a subliminal sense of where the light is coming from. His goal is to make it simple. It is the hardest of all goals to achieve.

"I have had jobs that have come with a five-page letter telling me what to do. I am to shoot a TV dinner straight on, no shadows, no distortion. The letter tells me how many peas I am supposed to have on the plate."

As time passes, however, the detailed instructions become less frequent. Arthur Beck has become recognized as the master of a superb style. No one can make food look more appetizing than he can.

"Recently, for example, I got an assignment from *Good Housekeeping*. A lot of different kinds of food. They said to shoot it any way I wanted."

Any way he wants. One cherry tomato breathes out dew at the savage end of a silver fork. Two bits of broccoli become a

sonata on the cutting board. French bread becomes a sculpture set off by sardines and half a lime. These things from everyday life approach the quality of fine painting. Their colors are richer than in everyday life.

"That's because my lights are warmer than daylight. Daylight is very cold."

The lighting is not an offense against honesty. He hates trickery, but sometimes he has to use it.

"Once in a great while, I have to put on glycerine or oil. But that's not what's going to make the photograph."

What makes the photograph is design. A sense of design not learned in any school but something that has come naturally to Arthur Beck. He designs on the glass and can compose well in the 35mm format.

"The photograph is created through your lights and through your eyes. A client is buying your eyes."

He knows he is moving more toward art, but he wants to keep the image clean. He doesn't understand why food can't be appetizing and a work of art at the same time. He wants to bring the honesty he directs toward food to all his photographs.

"My idea is to take an ordinary everyday object and surprise people with it. I want to stop people short. I want them to look at my picture of eggs and say to themselves, 'Good lord, I never realized eggs could be so beautiful.'"

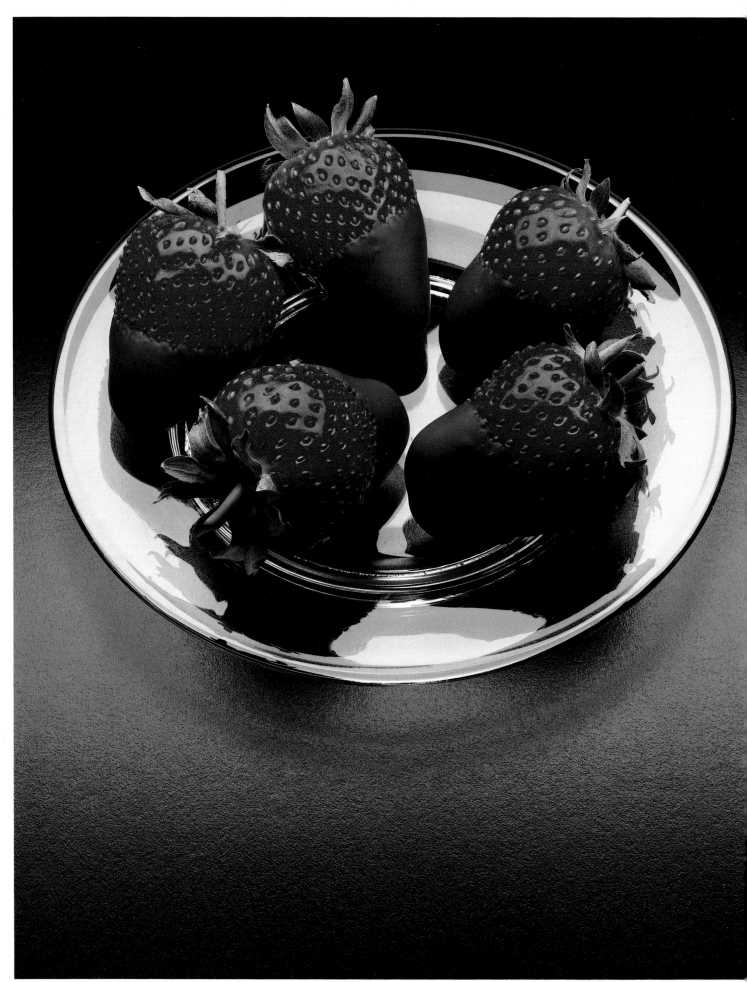

Strawberries, for Sheraton brochure.

STILL LIFE

Gary Perweiler

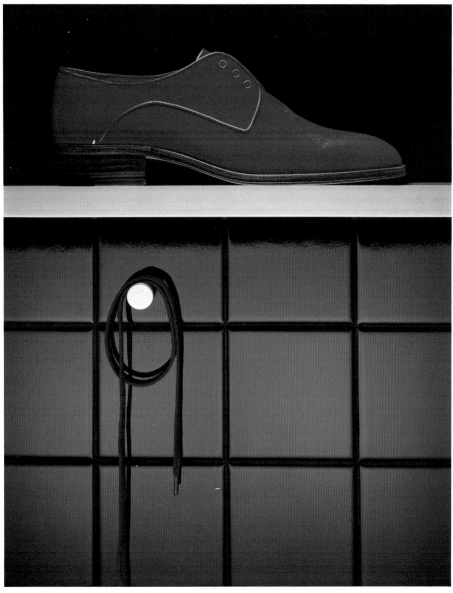

Man's red shoe, for Gucci.

He is interested in the object and nothing else. So Gary Perweiler comes in on the object. On the ground-glass viewing screen of his 8 × 10 Sinar, Gary Perweiler inspects the object. Whatever it is—an egg, a shoe, a glass of beer—he is going to make that object show itself in a way never seen before.

The studio is upstairs, hidden away in a cast-iron building on one of those forgotten stretches of lower Broadway. Gary Perweiler fools around, shifts a light three inches, puts more tilt on his camera's tilt front. Enthroned in the center of his gaze is a freshly prepared hamburger sandwich.

"Some objects are naturally exciting while others are drab and mundane. In the past, when I was given something boring to shoot, I would grope around and be lost. I couldn't deal with it. But I get better the longer I do this. I can put my style into more things."

In the glass, the hamburger is beautiful, symmetrical, mountainous, domed like a Byzantine church. Too bad no one will ever eat it.

"Still life is a problem-solving occupation. Every object has its own problem. The more things you investigate, the more knowledge you accumulate. When you master one subject matter, it opens up a hundred other possibilities—for other pictures later on. Gradually you expand your vocabulary."

He talks easily, lightly, giving an impression of youth and vigor, of someone who gets a kick out of life. But he wants that life to be ordered. He says he can't stand clutter. That was why he gave up painting—the medium was too messy.

He was born in Newark and attended the Philadelphia College of Art and Design, where he studied Swiss graphics under

Herman Hoffman. His childhood was spent moving from one place to another, thanks to a father who was a Marine Corps fighter pilot. Gary Perweiler says that lifestyle gave him a frivolous attitude. He could never take anything seriously when he knew he would be gone in a few months, a few weeks.

"Ever since, it has been my aim in life to get control over it. It's silly to think that you can ever get total control, but that's what I shoot for."

It shows up in his pictures, a drive toward total control. Or as he put it with pardonable exaggeration: "I'm hard-nosed, hard-headed—and hard edged."

It has made him a minimalist, as he calls himself. His minimal colors strike with a shock as they leap out of flat backgrounds. Or this is his training in Swiss graphics, concerned as it is with arrangements of space. As he goes on talking, he begins to sound as if he didn't photograph objects at all. As if he were a portraitist of spaces.

"From the Swiss I learned how to deal with space. How objects exist in space. Positive space against negative space, organic tensions versus areas that are flat. I learned how to take things from nature and bring them into a new harmony. How to subtract elements from a total picture to make it more legible. How to say the most with the least."

In Perweiler's opinion, Swiss graphics, European graphics, have made brilliant advances because they have had to. In a jumble of languages such as you find in Europe, communication must often be by graphics. Thus design becomes a universal language—one spoken also in the United States.

"I think in general the most successful pictures in advertising—

51

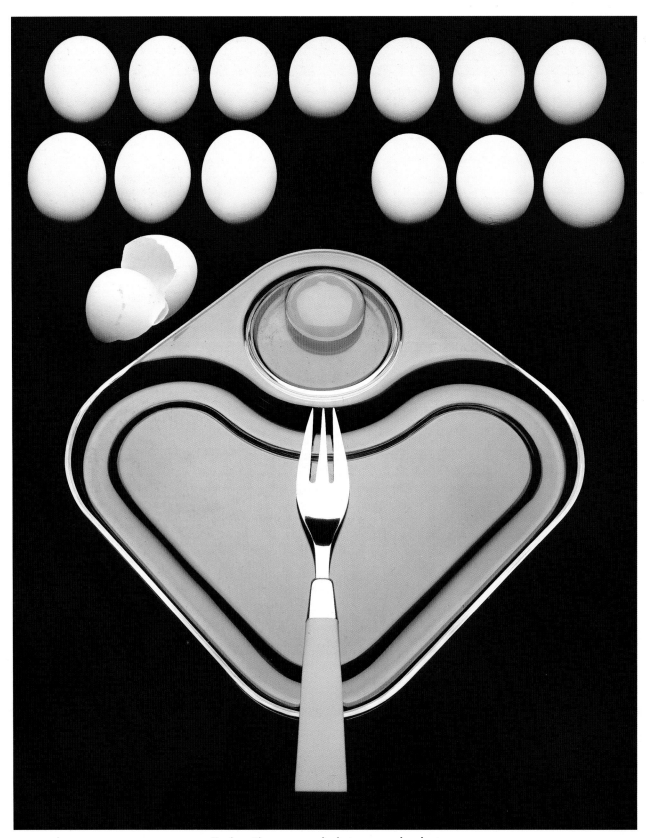

Fork with eggs and plate, sample shot.

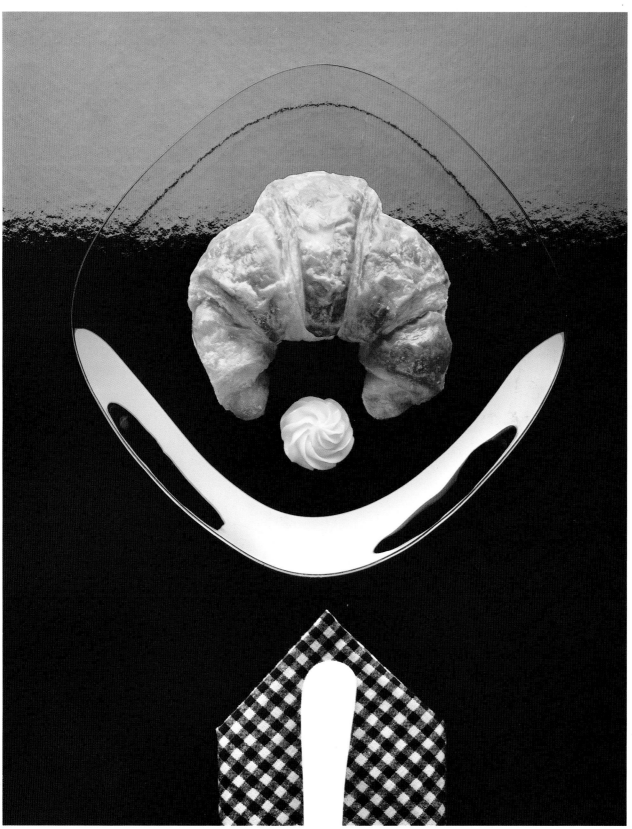

Croissant and butter, sample shot.

in still life, in particular—have that sense of space, of objects in three-dimensional space. The people the advertisers are trying to reach can relate to it. People understand three-dimensional space because they live in it."

A picture appearing in an advertising format is submitted to violent competition. Will it attract attention among all the others? A person living today is bombarded with thousands of images.

"You have to outwit the reader, the viewer. You have to strike him with an image that will stand out from the clutter. If it's a clean, strong, graphic image, I think the person will stop and look at it."

Yet here is the paradox. This arrangement of space that attracts attention does not depict the space that people live in. It is a flat, two-dimensional space. It lacks the third dimension, depth.

"Objects become more interesting when they are placed against a surface that is clean. I take a picture that is flat, and I can add a reflective surface and the picture still remains flat, the perspective is still flattened, but you see reflections, which give a sense of depth although it is not exactly spatial depth. Or depth can be captured with colors, the dark colors that recede contrasting with the light colors that approach. To produce a third dimension in a picture, you have to have a dominant foreground, a middleground, and a background. In my commercial work, I am constantly producing pictures that have a depth that is not necessarily the third dimension. There is something in my nature that likes to flatten it all out, make the picture two-dimensional."

The depth provided by colors or reflections is an illusion, optical

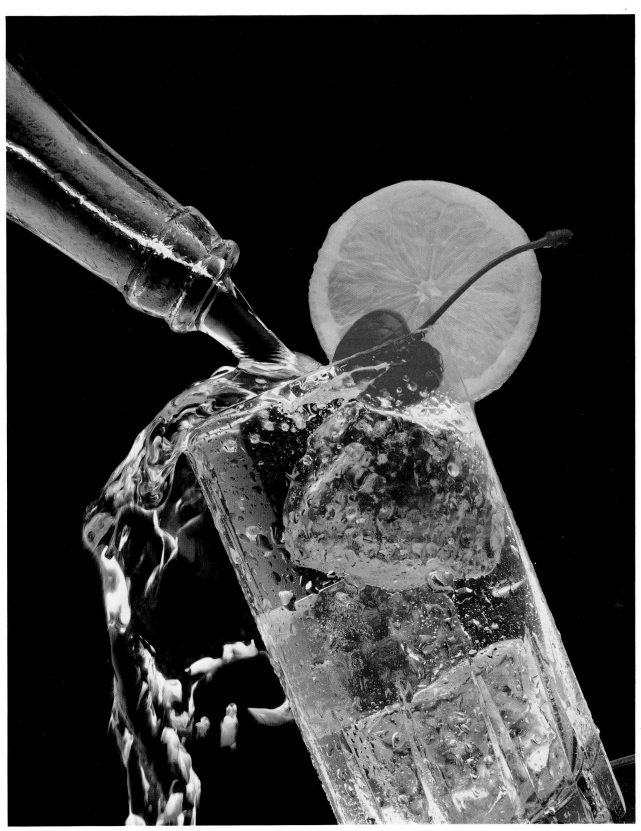

Lemon and water, sample shot.

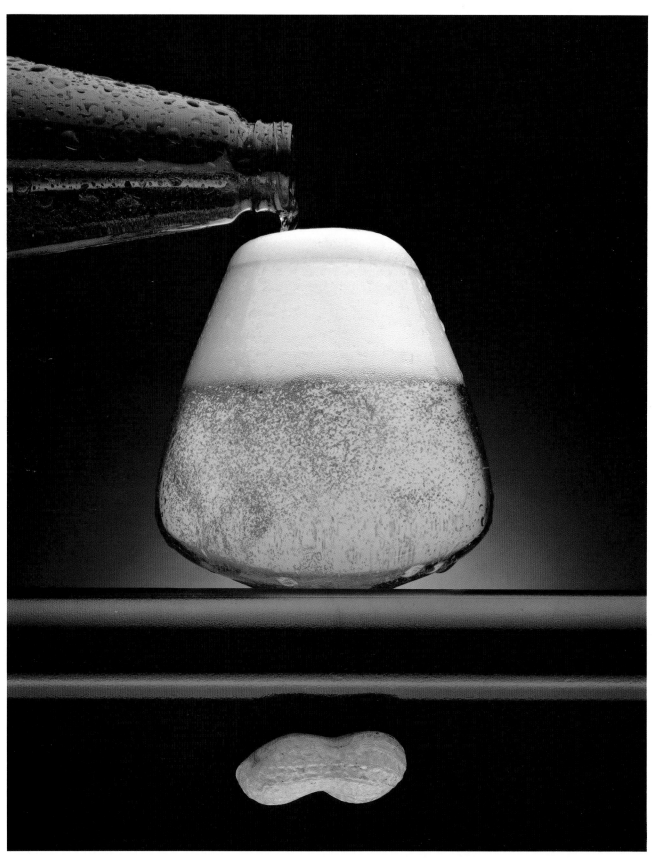

Beer and peanut, sample shot.

or otherwise. Perweiler is a master of illusion, created out of objects reduced to their essences. He is a seeker after mystery.

"My pictures are like posters in their graphic simplicity. By making posters, I am trying to evoke a strong immediate response. Sometimes you can make a boring picture because things become too simple. I am always struggling to make things more interesting. In one of the Gucci shots, I show fingers coming through a Venetian blind. Why are those fingers there? In a photograph of a glass of beer, I featured a peanut."

Why a peanut? Because it is a solid against the soft liquid of the beer. Because its one shade of gold shows the beer as golden too. Because the viewer understands that he might eat a peanut while drinking the beer. The peanut, brought to life by lighting, offers the picture its shell as a contrast in texture.

"Geometry is what permits pictures like mine to work. But just as important is the interplay of textures. The most crucial part of making a picture is for me the play of texture and shape, the opposition of flat planes and organic areas."

To inspire the interplay, Perweiler is constantly on the move, poking, prying, experimenting.

"I never have the picture all figured out in advance—the object right there, the lights right here, and so on. I put the object in front of the camera, and I study it. I drop it down, I lift it up. I add something else and shift the lights. I move it over, I move it back."

For Gucci, he did a picture of some ballpoint pens. By the time he had finished with them, worked out his problem, the pens had become elegant thrusting shapes as large as logs.

"The background of modeled flat black as used in the beer shot just wouldn't have worked with the pens. For them, with their harsh and brilliant highlights, I needed a background that would show a certain subtle repetitive texture."

To get his background, he used more pens, laying them out in a geometry of diagonals that would have been overwhelming if he hadn't lighted them so softly that they almost vanished. Perweiler's lighting enters his pictures as one of their ingredients—shapes and spaces, textures and lighting.

"Lighting is everything. I want the light to create the shapes I photograph—and bring out beautiful highlights. And yet when you deal in shape and space the way I do, the lighting becomes almost subliminal."

Sometimes he works in chiaroscuro, and then the lighting provides more of an obvious focal point. Either way, his pictures carry the signature of his lighting style. The light is clean, emphasizing the singularity of the object. These are ordinary objects—and at the same time extraordinary. Perweiler worked for hours to turn the head on his glass of beer into a foam of perfect symmetry. His stylist spent a day combing the bakeries for a croissant with just the shape he wanted. After placing it on a plate with a perfectly swirled circle of butter, he realized that the napkin in the picture would have to be checkered. This is how he plays around, achieving organic tension, persuading surfaces and textures to react one to another. This is the restless imagination that realizes how desperately a silver telephone calls for a red rose.

Gary Perweiler got into photography at the age of twenty-five. After finishing school, he worked as an art director in an agency. He was painting, practicing graphic design, unsure

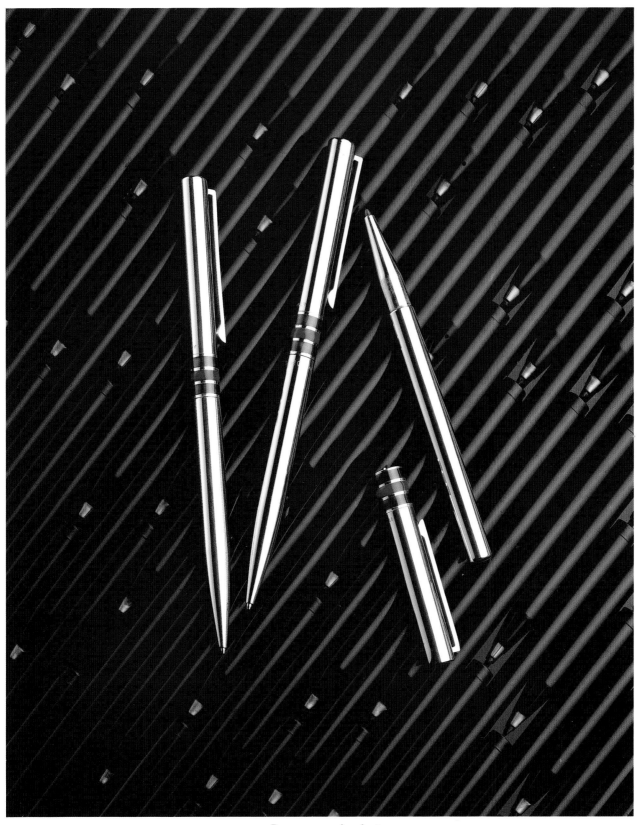

Pens, sample shot.

Manhattan, sample shot.

about what he wanted to do. He considers this a late age to enter the field.

"If I had started when I was twenty, I would probably have become a fashion photographer. Fashion photography is flamboyant, very adventurous, youth's dream of life in the fast lane. But since I was late getting started, I went into still life. With still life you can get started quickly, exercise more control over the picture-making process, and begin to pay the rent."

There is no end to the demand for the photography of products, one practical reason for going to still life. Another is that art directors are more willing to give beginning photographers a chance if they are in still life. It is purely a matter of expenses.

"Let's say I've been asked to shoot a bottle. If the art director doesn't like the way I did it, I can reshoot it—again and again if I have to. I don't have to worry about hiring models, hairdressers, makeup people, getting a wardrobe together, all that."

Gary Perweiler will talk about the practical considerations that lured him into still life, and then in the next breath admit that his love affair with objects springs out of impulses that are part of his very nature.

"Maybe it's in the genes—German ancestry, and they say the Germans have a sense of order. That's something I have to do, bring order out of chaos. That's why I studied graphic design. I'm very ordered in my photography . . . in contrast to my life."

At the same time, he doesn't want to make any exalted claims about what he does. "There's no use kidding yourself that you're in fine art when you're doing commercial art. A commercial artist has to make a universal statement readily understandable by the public that the agency is trying to reach. A fine artist makes a personal statement."

61

Still, he isn't sure. As a commercial artist's career develops, a vocabulary forms with it. The work begins to show a point of view. It begins to vibrate with another tension—between what the client wants and what the photographer wants. If you manage to capture both, you've become a photographer. You're no longer just a "shooter," as Perweiler terms it.

"When you start out in this business, you're just a shooter. You just follow the layouts because the art directors are nervous. In time, you develop a point of view, and if you're lucky, they will like it in the agencies. They will want to exploit it rather than suppress it. New York is a funny place, very conservative in its sense of graphics. On the other hand, they will hire you in this city for who you are."

In time, too, still life is no longer the easygoing operation in which you can shoot the bottle a hundred times if necessary. Perweiler's studio is as full of people as if he had gone into fashion. There are clients, agency people, his own studio assistants, the home economist, the stylist, the model maker. Perweiler has asked his model maker to fashion the ultimate hot-dog roll, more perfect than anything that could ever come out of an oven. Wood on which mustard will look right at home.

You have to be up for the work, he says. You have to be in the right frame of mind. "To make things work, you have to feel good. You have to be at peace with yourself. You can't be in a bad mood or full of hostilities. Still life is too tedious. You can't be on edge like that."

But the work drains him. At the end of the day, all he wants to do is go home. "I love to take pictures and hang out with my dog. I've been married for two years now, and I like to hang out with my wife, too."

His third wife, the painter Cynthia Gallagher, is in some ways her husband's exact opposite. Working with an abstract expressionist palette, she lays on great gobs of paint, creating chaos out of order.

Gary Perweiler tries to make a universal statement that expresses a personal point of view. Put that way, it sounds like an impossibility. But isn't it exactly the mark of the great commercial photographers?

"I like to take objects and put them so they express all my design principles. In the picture with the eggs, I wanted to get a certain mass in it. An organic tension at the top. A thrust, reaching downward. And minimal on the color. In fact, there is only one color, the yellow."

Or again: "I like to play on reflections. I like turning silver to white."

Commerce fades into art. You can no longer tell where one ends and the other begins. You can get Perweiler to admit this.

"I guess so. It's the way you get to feel about it. It's commercial, but maybe a little art has worked its way in. To survive in this business, you have to be prolific. You feel the pressure always to say it in some new way. It drives you to keep stretching your limits, always to go one step beyond."

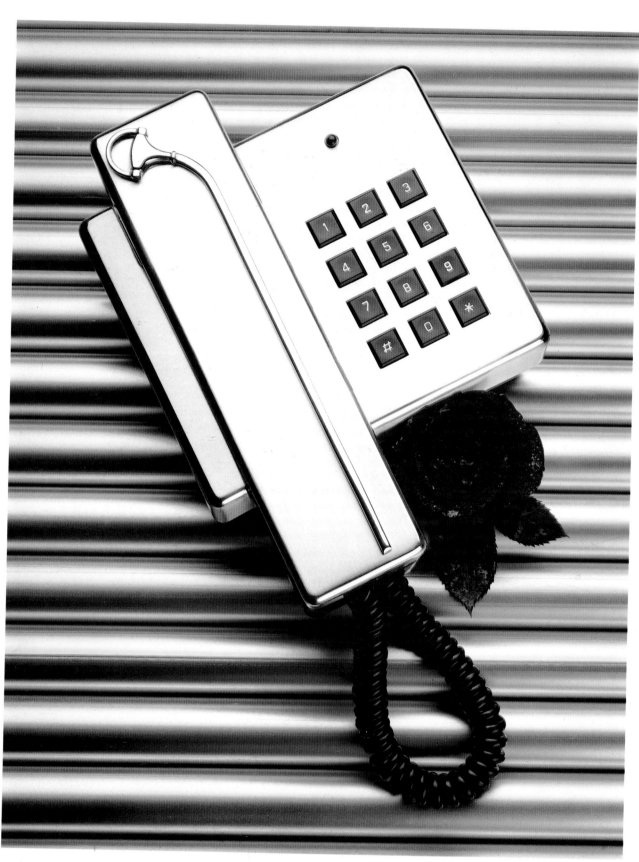

Phone and flower, for Gucci.

PORTRAITURE

Anthony Edgeworth

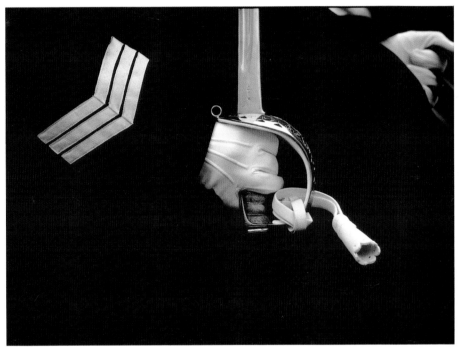

Detail, from *The Guards*.

A portrait comes out of a human encounter, often of a special kind. If the subject is a busy, important person, the photographer may not have a lot of time. No matter how short the session may be, the portraitist has to establish a relationship with his subject. Anthony Edgeworth is careful about getting ready.

"I rarely do anything without a lot of preparation. Naturally I think about film, lenses, lighting. I spend more time thinking about the person, the situation. I get there and I practice, walk it through."

But when the moment comes, he wants it to be unstudied. To hear him tell it, he sounds almost as if his preparations are thrown out the window.

"I don't like balancing the person in perfect position, balancing for strobe, putting on the neck braces, and the person sitting there with the environment totally arranged. I don't like to make it too much of a setup, where nothing spontaneous can take place."

He knows there are portraitists who linger over their photographs. He sees that sometimes they get "strong, very punchy pictures." But that is not Edgeworth's way of working. He takes great care in getting ready, and then to get what he wants at the critical moment, he throws it open to impulse, to chance. You can ask him, what does he want? And he gives you an answer.

"I want something to happen between myself and that person."

In the portraits you can see that something has happened. They are vivid, surrendering, a kind of contradiction of their own. These people have been augmented, shown at their best, made into stars. At the same time caught as themselves—participants in this one and only life.

Many of Edgeworth's subjects are already stars. If so, they have been photographed a hundred thousand times. Tony Edgeworth brings out something in them that has never been seen before. He rips his Nikon off its tripod for a great grab shot if he can get it. He wants them looking alive—and most like them-

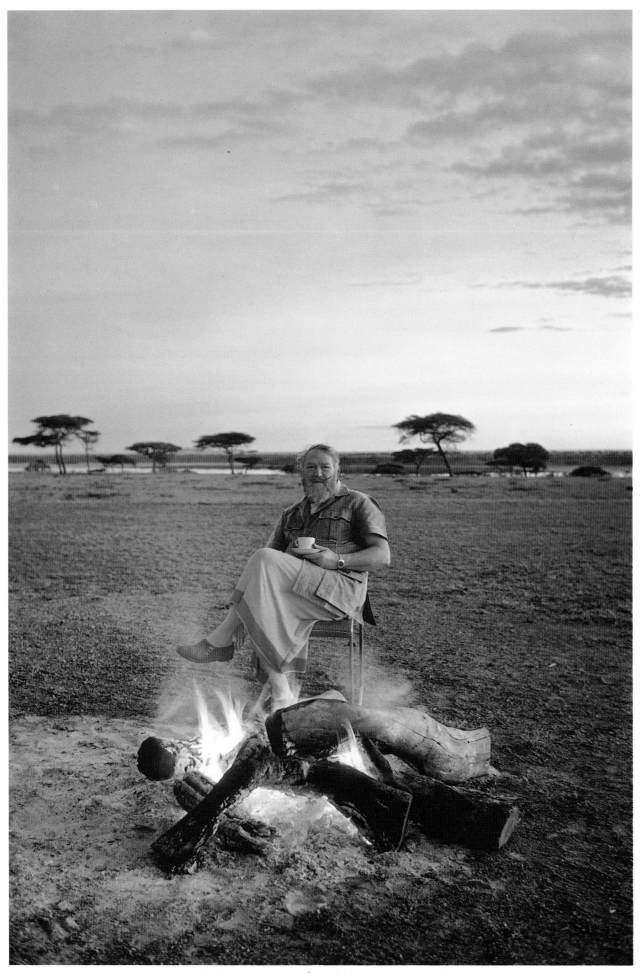

Professional hunter in Africa, private work.

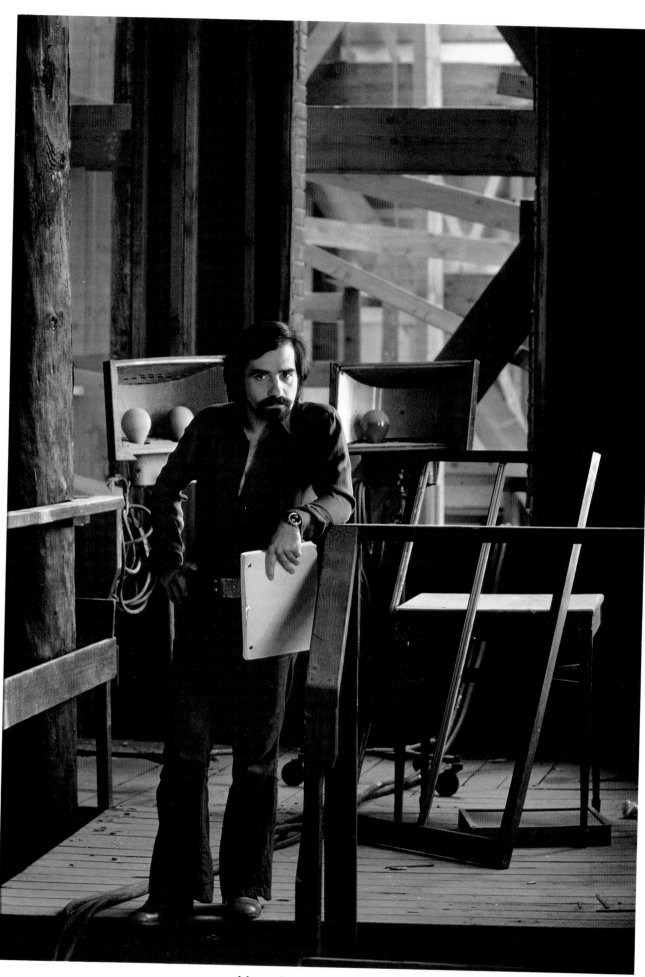

Martin Scorsese, for *Esquire*.

selves. Tony Edgeworth has an affinity for actors. Once upon a time he went to Hollywood, intent upon becoming an actor himself.

His studio is on the top floor of an anonymous structure across Fifth Avenue from the Empire State Building. The colossal spire can be seen through his skylights, rearing up yet seeming to hang right over him. Tony Edgeworth squints up at it. "It's a shot I'm saving," he says, "a shot I have to take some day." At the noon hour, his elevator operator goes to lunch. Walking up five flights to visit Tony Edgeworth feels like climbing the Empire State Building.

He has his studio, but he does a lot of work on location. He has always had a camera. In Dover, Delaware, where he was born and raised, his grandfather sold cameras. He himself was always taking pictures, "without thinking too much about it." As for a career—well, there were all sorts of possibilities. For a while he rode show horses. He was a drummer and had his own band.

"It's funny how things come together. Certain influences just seem to go to work at the right time."

That's what he says now. He is lounging in his studio, gruff but hospitable, a big man—or one who gives an impression of being big. His yellow sweater supplies a splash of color in an antisepsis of white walls. In the late 1950s, he was somewhere else—in Berlin, in the U.S. Army, in a closed city where you couldn't go anywhere else.

"I wound up with a Russian Contax camera, passed on to me from an officer in the Intelligence Section. Whenever I had a chance I was out shooting—with Kodachrome ASA 12. The colors you could get out of that old film were great. You could sit the camera on a stein of beer and catch shafts of light coming through the door. The results just knocked me out. To me they were as good as anything I saw in magazines. The thought came to me, it would be fun doing this for a living."

69

First there would be a few side trips, one of them to Hollywood. Thinking about doing something in front of the camera. But of course you couldn't just step into the movies and, like so many others, Tony Edgeworth had to get a job doing something else. In his case, it was selling men's clothing. And then he was moving on, selling men's clothing in the Middle West, his territory covering thirteen states. You had to present an image of successful clothes. You walked in slick in your custom-made pinstripe, and you would see the clients looking at you from far away. You had to be friendly, come across as straight, show a sense of humor. Most important, you had to size up these people if you wanted to make a sale, figure out what was going on in their minds.

"It was hard training in the art of studying human beings. I mean you really had to *look* at those people."

That and everything else kept pulling him back to photography. When he finally decided to give it an all-out try, he had one of those strokes of luck so often reported as such by those who have gone on to do outstanding work. He was taken on as studio assistant by one of the great names in the game. Pete Turner was the guru for Anthony Edgeworth.

"Pete Turner really taught me how to work with a camera. He had tremendous style. And great variety in what he did— personalities, still life, travel. I watched the interesting ways he approached the object, the subject. He had a far-reaching influence on me, more than I realized when I first went out on my own. To become a travel photographer was my first idea."

Travel—why not? Edgeworth remembered his two years in Berlin, the stimulus—for his pictures—of roaming through foreign lands. He thought Europe would be a great place to work.

Travel led to work with magazines. For a time, Edgeworth was exclusively a magazine photographer. He had an assignment from *Esquire*—it was his own idea—that he should go to England and do something with the Queen's Guards. Well, not exactly the Guards themselves, those troops like no others in

the world, but rather their tailors. Who makes those fancy uniforms?—that was what Edgeworth was curious to find out. Who applies and repairs that elaborate gold braid and shapes those high bearskin shakos? Questions that might come naturally to someone who had spent six years spreading style in the Great Plains.

Of course the Guards would have to be photographed, too. He would have to show the results of all that tailoring. But that wasn't so easy to bring off.

"I had an idea for what I thought would be a great picture. I would take one of the Guards, stiff and straight, and place him next to a girl right out of Carnaby Street—porcelain skin, high cheekbones, see-through blouse. I wanted to show the contrast between something trendy and something permanent, between the fad of the moment and a staid old family heirloom."

Edgeworth soon discovered that where the Guards were concerned, nothing so frivolous would be permitted.

"They are an elite group, very conscious of their dignity. I had letters of introduction, everything I thought necessary, and they turned me down cold. They gave me the impression they could do without that kind of coverage."

He was puzzled by the Guards—and by now fascinated. He hung around. He photographed a Life Guards officer riding horseback in Hyde Park. They talked, and the officer consented to be photographed in the barracks. That was the beginning of it, a study of the Guards to which Anthony Edgeworth devoted seven years.

The result was *The Guards*, published by Crown in the fall of 1981. This handsome presentation of the Household Division, as the Queen's Guards are officially called, is portraiture expanded, applied to an institution, converted into chronicle and history. It is an affectionate portrayal, interested and amused, yet offering a serious view of men whose public lives remain stylized in ritual within the chaos of the twentieth century.

71

Restaurant owner in Italy, private work.

Ralph Lauren, private work.

They are men who are in some ways the very opposite of Tony Edgeworth himself. Is that why he felt compelled to portray them in such detail?

"In my own life, I'm sort of cluttered. I can't balance my check-book—or I pretend I can't. I'd rather buy the ticket at the airport than plan ahead. If I had become an actor, I would have wanted to step onto the stage and knock 'em dead without having to memorize any lines. I want to feel the experience of life without having everything organized. I want the fear of being unprepared."

Pete Turner, as Edgeworth says now, taught him to study his lines. Beginning with this simple maxim: "You put the camera on a tripod and then you level it." But of course there was more, much more—to know lights, to work with strobe. To grasp the effects of natural light.

"Most important, I got from him a sense of how to organize things with a lens, a feeling of balance, an idea of what to look for when I'm shooting."

Turning the pages of *The Guards*, you see that he got some-thing else from Pete Turner—his wide range, his ability to han-dle every kind of photographic situation. Portraits, yes, but everything else. The jobs he gets demand the full range, he in-sists, and he can show it in the carousels that serve him for portfolios. He has put together a portrait carousel, and five others—industrial shots, executives and workmen on the job, on tankers, on oil rigs, whatever. He has a tray of travel. And a tray of fashion shots, men and women. "I do everything," he says, "except still life."

Then in the book you strike the still lifes. A display of gold braid. The hilt of a sword showing the word Wilkinson, the name of the classic sword-maker. "Yes," Edgeworth admits, "that's what I don't do."

Or is it a portrait of braid, of a sword, of an object given per-sonality? A Guardsman is shown, just his chin strap and a fragment of a face. A portrait becomes a still life. The categories blur and fade, get lost in one another. Is this Anthony Edgeworth

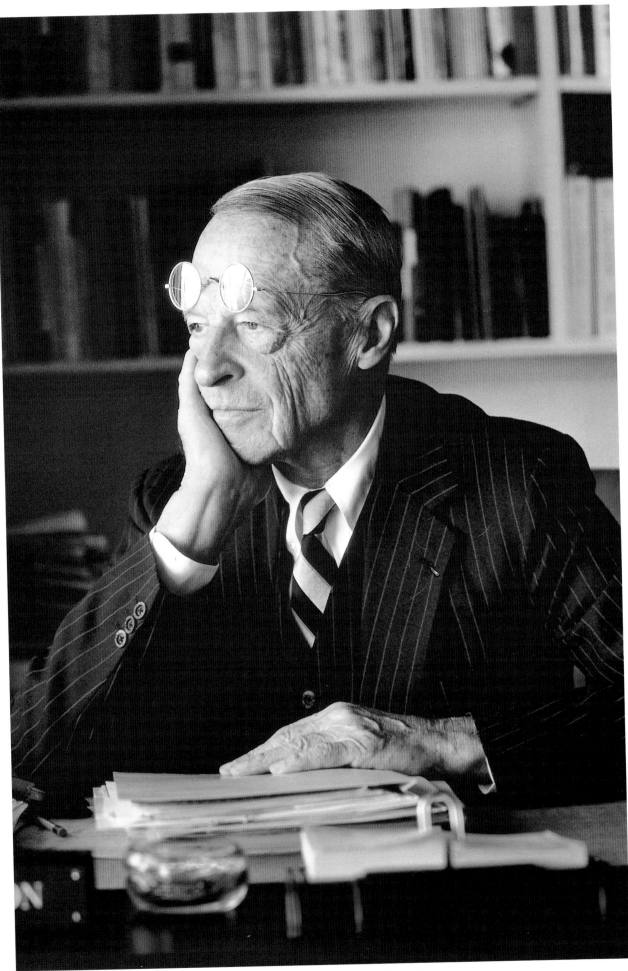

Francis T. P. Plimpton, for *Time/Life*.

John Le Carré in London, private work.

asserting that life, like himself, resists being organized?

"The chin strap, or curb chain. It's a portrait, but it's a graphic also. It's representative, symbolic of the Household Division. They all wear the curb chain. It's a portrait, but its impact is symbolic. It was taken in direct sunlight. I don't want to put anything between the lens and the flesh tones, except perhaps a polarizer to intensify the color.

As he talks, you get the impression that the heart of the problem is somehow right there, in the conflict between planning, organization, and the stroke of luck that bursts unexpectedly out of the chance moment.

"I've had my organized periods, sometimes too organized. A couple of years ago, [someone] was going through my photographs. He said, 'Well, you need a change, everything looks the same. You need some life, some laughter.' He was right. Everything had become static. I had become the victim of the instruments, tripod and camera. I might as well have been Mathew Brady, fitting people with neck braces."

But the instruments are necessary. He cannot dispense with planning and organization.

"Sometimes it's the film you wish you could get away from. At other times, it's the camera. Somewhere between speed and aperture you're trying to capture a moment, establish a certain feeling. Or you want everything clear and precise, which won't happen unless the light is just right and it doesn't look like you shot it at high noon. For my format, I like to use long lenses, but long lenses are not fierce lenses. You really have to take your chances."

Everything would be easier for Edgeworth if he didn't have such a mania for natural light. Light—and lighting—he could write his own book about it.

"I've looked at Pissarro's paintings and wondered at what time of day you could get with a camera what he got with a brush. Black cobblestones shining in the rain. Muted grays and browns. Mixing the colors half a stop under, you're muting

them, adding some gray. Taking it the way the light meter reads it, it's not the same—it's just not going to give you the same look. Maybe in the first light of the morning, with the sun striking at an angle, you might get something close to Pissarro.

"I never use lighting except in fashion. Strobe is a cheat—you know it's not real. Some of the things you can do with strobe are interesting if you like special effects. But to get the real feeling of a person, you have to use natural light."

His preferred film, Kodachrome 25, is not fast. In low light with a long lens, how can he avoid using a tripod?

"Well, the solution might be that you have to get rid of the long lens and move in closer with a shorter focal length. Just get a highlight off the glasses, something with a mood to it, something that has spontaneity."

That is what he is after, that precious spark of spontaneity, that moment of real life.

"Shooting people takes a certain amount of nerve. You have to overcome a certain resistance on both parts. They get to know you, and then they'll do what you ask them to do. I'm not saying I'm not manipulative. I'm definitely manipulating. I'm designing. Putting people exactly where I want them. But in the middle of all this, sometimes something unexpected happens, and you have to grab it."

So the organizing part of an assignment is confined to the planning and preparation. Edgeworth will take hours preparing for a shooting session that will take only a matter of minutes. That was the way it went with Frank Borman, the astronaut, now president of Eastern Airlines.

"I practiced. I walked through the paces right where I was going to shoot. I spent two hours getting ready. When Borman appeared, we gunned him down. We shot him silly. Eight rolls in twelve minutes.

"I paced back and had him walk toward me and shot him with an 85mm lens. I asked him to take his jacket off. There he was in

his white shirt with his tie flying in the wind. He reminded me of those old shots of Charles Lindbergh.

"We didn't bother with anything indoors, anything on the contemplative side. I got four different formats outside, going in tight with everything blurred, everything out of focus, except him. What I was after was something with life in it. I wanted something real."

Going out on a portrait assignment, as Edgeworth said, you never really know what you're going to get until you get there. Sometimes he has been lucky, as in Truman Capote's richly decorated apartment, providing a lavish setting. And Capote himself: "A great celebrity with tremendous presence, a person who knows how to pose. It was one of those situations that kept getting richer and richer. At the end of the session, we just sat back and laughed."

It was a session in which everything came together. Yet Edgeworth, typically, couldn't keep from thinking of other photographic possibilities.

"Who is to say that Capote wouldn't have been just as great a subject if I had met him outdoors wearing an old cardigan sweater, carrying a bag of groceries? That would have made a hell of a picture—but you have to know how to get it. You might set up a tripod and let him walk back and forth. Or you might simply pull a camera with a 50mm lens on it out of your pocket, set the shutter speed at 250, and have some feeling about what you're doing."

Other possibilities—the world is full of them. What Tony Edgeworth wants is to take some photographs for himself. He wants to shoot the city of Prague with its marvelous Baroque architecture. Or a graveyard of jet planes near Tucson, Arizona. With a sexy twenty-year-old girl, body oiled, primary colors in polarized light against the somber shades of mothballed jets. He is going to start doing things like that—just for himself— "once in a while. As soon as I get around to it."

Truman Capote, for *Esquire*.

BEAUTY

Gordon Munro

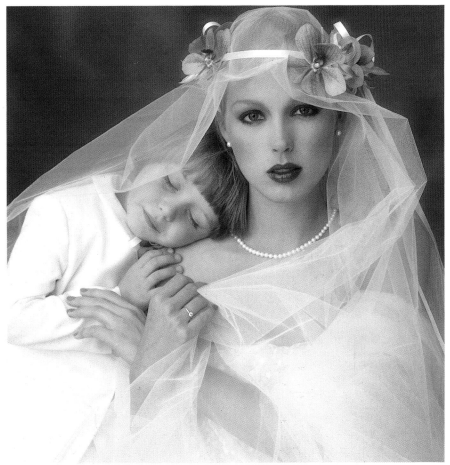

Kim Charlton and child, for *American Bride*.

I'm a still-life photographer with a beauty edge." Gordon Munro is appraising himself. He considers the implications. Still life, with its meticulous preparations. His subjects, the world's most beautiful women, treated as if they were objects.

"Obviously, I look at a person in a visual way. Not the way a writer or an actor would look at them. When I get to know people, I perceive them as human beings, as others do. But when I'm doing photography, I see them purely in visual terms."

But the face is not always just a mask. Sometimes Gordon Munro wants something to shine through.

"Sometimes you select not for surface beauty but for a certain quality of character. Certain models have a very strong character, and that character transcends the face, coloring the photograph, affecting it tremendously."

Gordon Munro sits at a table in his New York studio, high in a building on Park Avenue South. He is contemplative, soft-spoken, his London accent still sounding through. He has come a long way from the boy whose high school chemistry teacher persuaded him to use chemicals—in a darkroom. Fascinated, he watched a print materialize on photographic paper.

His father had a camera he let him use. He fooled around taking pictures, more interested in the technique than in the content of what he was shooting. London was talking about the marriage of Anthony Armstrong-Jones to Princess Margaret. Besides being charming and presentable, Armstrong-Jones was a photographer.

"He was an excellent photographer—and still is. In all the publicity over the marriage, I happened to see a copy of his book, *London*, his photographic study of the city. The book just bowled me over. It had never dawned on me that people could

take pictures like that. My impression was that all photographers had shops on street corners where they took pictures of dogs and weddings."

Fashion photographers had been gentlemen, Cecil Beaton a prime example, Tony Armstrong-Jones another, upper-class fellows who could afford to play with cameras. Henry Clark took pictures of very elegant ladies, always in an ambience—in palaces, at garden parties.

One surprise followed another, and the next revelation disclosed to Gordon Munro what the camera could do with high fashion.

"I was the son of a builder. What I had intimate knowledge of was reinforced brick."

Suddenly fashion photography went through a change. Gordon Munro tells the story very well. Three terrorists appeared out of London's East End. David Bailey, Terrence Donovan, and Brian Duffy, all working for Condé Nast, for the American *Vogue*. They had cockney accents, they were abusive, and they became the darlings of London.

"Brian Duffy was a hero of mine. Unlike Henry Clark, he made all his pictures in the studio. They were very clean, very witty, straight to the point."

Unable to find the kind of opportunity he wanted at home, Gordon Munro felt the pull of the American fashion magazines. They drew him across the Atlantic. His arrival in the New World was followed by one of those strokes of luck so often reported by successful photographers. He was taken on as studio assistant by one of the masters, Irving Penn.

"For me it was marvelous. Here I was brand new in America and in the best possible position to learn everything that

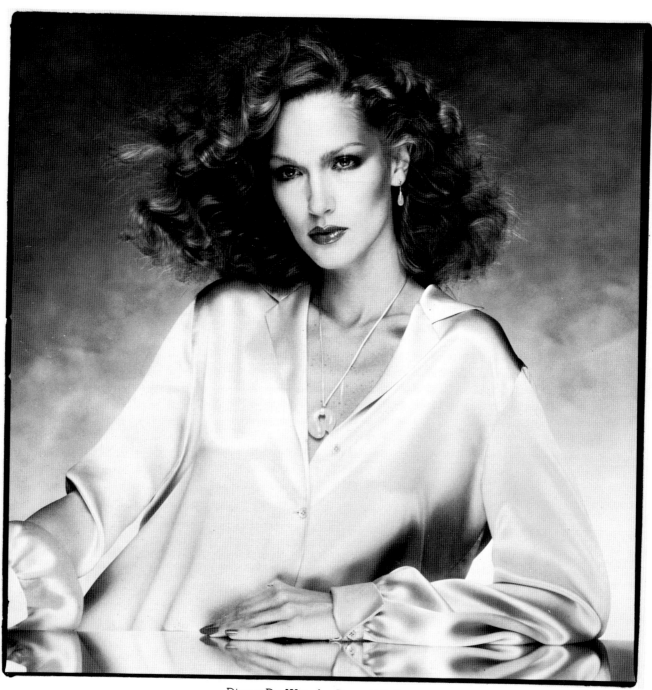

Diane De Witt, for Bonwit Teller.

America had to teach me. My only problem was that I was not to do any photography myself. I was to be strictly Irving Penn's assistant studio manager. As he pointed out to me, his pictures would depend also on me. I should become as excited as he was with what he was doing. If I were taking my own pictures, I would be going my own way. Not working with him."

This was fine for the moment, but it meant that when the time came to leave Irving Penn—truly to go his own way—Gordon Munro had no portfolio. Two years as a freelance studio assistant gave him enough spare time to run tests. Gradually testing turned into work, assignments on his own, and work slowly ousted the assisting. After a few lean years, there he was, with a studio of his own. Beauties were there, holding poses, waiting for the flash of his strobes. This, as he had come to realize, was what he had always wanted to do. To photograph beautiful women. Their faces. Framed in apparel.

"People often want you to do beauty shots with bare shoulders. I try to talk them out of that. I haven't done a head shot in years without clothes. I used to do it, and I hated it. It's the clothes that add that extra something. Not necessarily saying anything in particular. But offering a texture."

Furs hang in Munro's pictures, showing their lavish weight. Silks display liquid shadows. His camera captures the feel of fabric—and in black and white, too. But the truth is that he is fascinated by more than texture. He has a tremendous feeling for high fashion.

"I sometimes wonder how the great designers seem always to be moving in the same direction. What influences are at work? Everything shifts together. Tastes change even in women's faces. I love shooting *haute couture* even if I can't say what produces it—or even what it is. But that's just what it is—

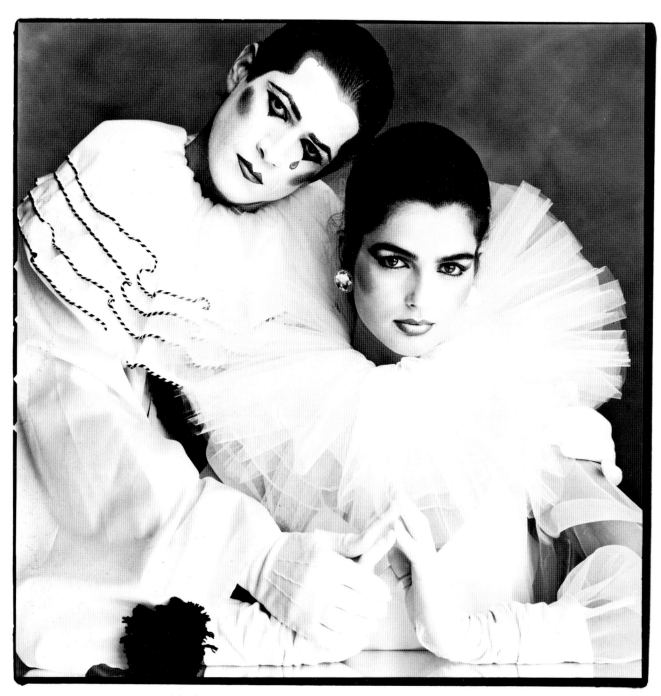

Mark Richardson and Eva Voorhis, for Bloomingdale's.

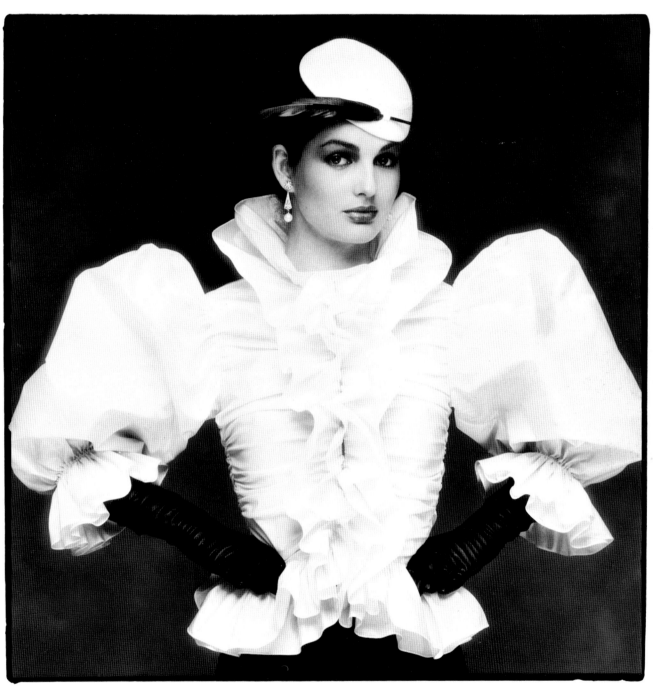

Eva Voorhis, for Bill Blass.

indefinable. It expresses a certain kind of imagination. When you photograph it, it's that imagination you have to capture."

Yet even when shooting high fashion, Gordon Munro puts his focus on the face. He declares that for him there is no difference between shooting fashion and shooting beauty. He sees certain clothes as calling for certain faces.

"I see casting as ninety percent of a picture. You can have the best hairdresser, the best makeup artist, a perfect arrangement with marvelous lighting, and if the girl is wrong, the picture won't work."

Talking about casting, he sometimes means everyone. Gordon Munro has his favorite hairdressers and makeup artists. He knows whom to call when the choice is left to him. A beauty shot can be a major production with ten or a dozen people involved—plus a client. They are studio shots, with lighting problems and all the techniques of still life. But Gordon Munro never finds himself alone with his camera and an egg.

"A beauty shot is a shared experience—we're all in it together. I find myself talking like Irving Penn used to talk to me."

Like much still life, his own style is clean, simple, strongly graphic. Is this the influence of Brian Duffy? What is more likely is that Brian Duffy appealed to Munro because of his own predilection for simplicity.

"I never had any other intention than to work in a studio. Whenever I was offered a job, I always saw it in my mind as a studio shot. When I was asked to shoot on location, I had to do a lot of internal reprogramming. I have this aversion to clutter."

He remembers that when he was an assistant, location photographers were using wide-angle lenses and getting everything in the picture while distorting the images. Some of this he found

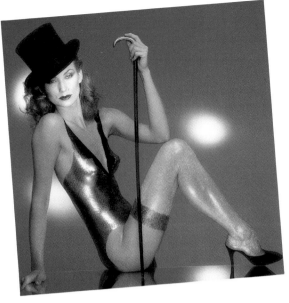

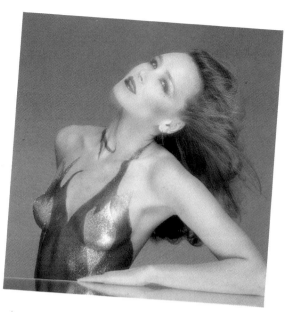

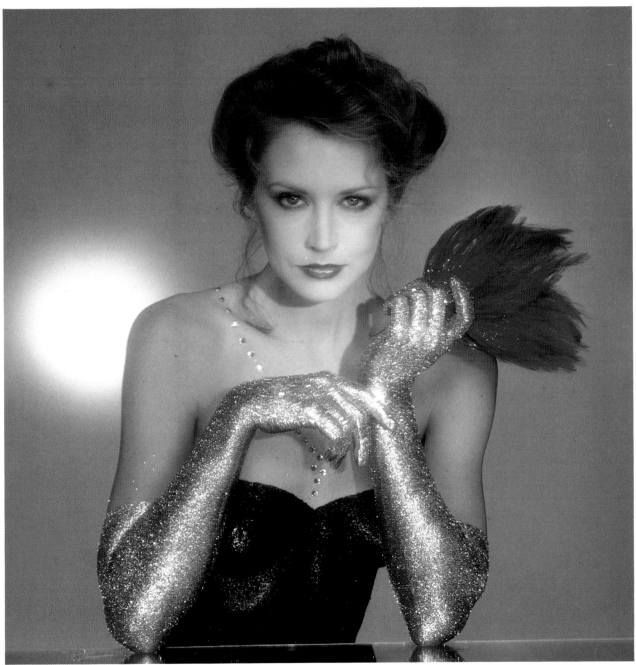

Anna Andersen (top left), Patty Oja (top right), and Lynn Brooks (bottom), personal work.

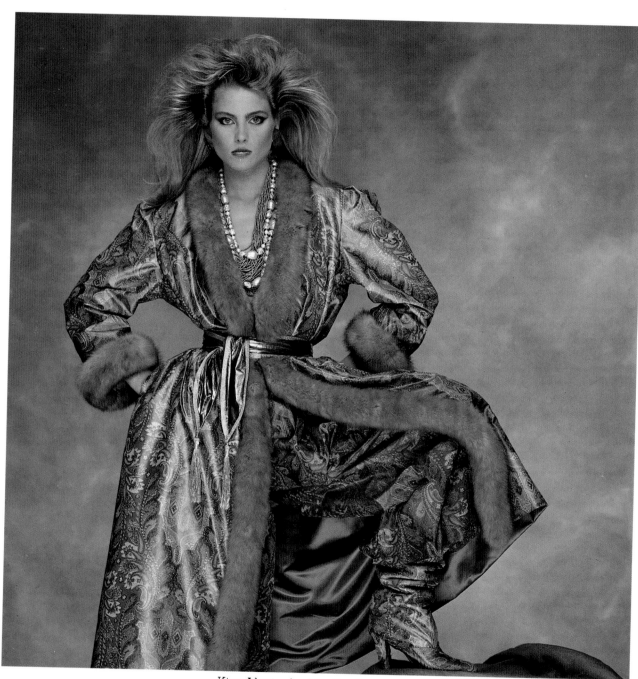

Kim Alexis, for Martha (boutique).

exciting visually—Art Kane's picture of a girl holding the sun in her hand, for example—but never thought of doing anything like that himself.

"Then suddenly that went out of vogue, and everybody broke out 500mm lenses. All at once location photography was no different from studio photography. The long lenses put the background so out of focus that it became merely a question of texture."

Outside or inside, he wants a very graphic composition. He achieves this in the studio with the clothes, what the model is wearing, with her just standing there.

"If it's a cropped picture, then I look at her arms, how the clothes fall, the way the collar frames her head. When I get my composition established, then I don't want the model to move any more. I want her to stay exactly like that. Then I like to work on the face. I want to take the picture when the face is at its most beautiful. To me that is a beauty photograph."

Yet the whole face isn't needed to make it a beauty photograph. Gordon Munro shoots his model under the dramatic ellipse of a great round hat. Nothing of her shows but her beautiful lips and the superb line of her jaw.

Or, in contrast, he shows almost the full figure, the model Kim Alexis wearing an extravagant fur-trimmed coat by Bill Blass. Gordon Munro has turned her into a barbarian, a mountain woman. The eye is directed to the face, to confront the savage gaze of an oread.

"I'm as much a stylist as I am a photographer, creating something that won't hold in place for more than a few seconds—while my assistant is taking the picture. We have to capture a shape, a form, everything coming together. I have framed the image, decided on the lighting. What difference does it make who presses the button? I am styling the model, making sure



everything holds in place. At the magic moment, I tell my assistant to take the picture."

Just as in still life, the lighting is crucial. Lighting a beautiful face, however, is a world away from lighting a glass of beer. Once upon a time, Gordon Munro used simple lighting, a single source in the foreground. Nowadays, his lighting is usually much more complicated.

"There is a sort of glamour that comes out of using several lights. I might put a spotlight on the face and have everything else subdued. Or I might have light coming from above and below, two completely separate lights, where the intensity is varied with each face. This used to concern me when my lighting was simpler. It didn't seem right to me that I should be lighting every model in the same way. Something told me that there is a best light for each face."

Nowadays, also, he is always experimenting with his lights, developing new and interesting ways of illuminating his compositions of people. He places one umbrella on top and another underneath. With the two strobe heads in each umbrella he can vary the lighting relationship in terms of eighths of a stop.

"I tailor the mixture to each face. With one face, the lights have to be equal in strength. With another, equal lights will create unpleasant shadows."

He checks the scene with quartz modeling lights to see what the strobes will yield. He always finishes with a sheet of Polaroid—not for exposure. Polaroid is not consistent enough for that—but to see how the elements of the picture relate to each other. To check on the lighting *relationships*.

He uses a Leica R-3 for 35mm, a Hasselblad for square format, a Sinar P for 8 × 10. He loves the old Deardorfs with their wood and brass fittings but doesn't like the fact that the focus must

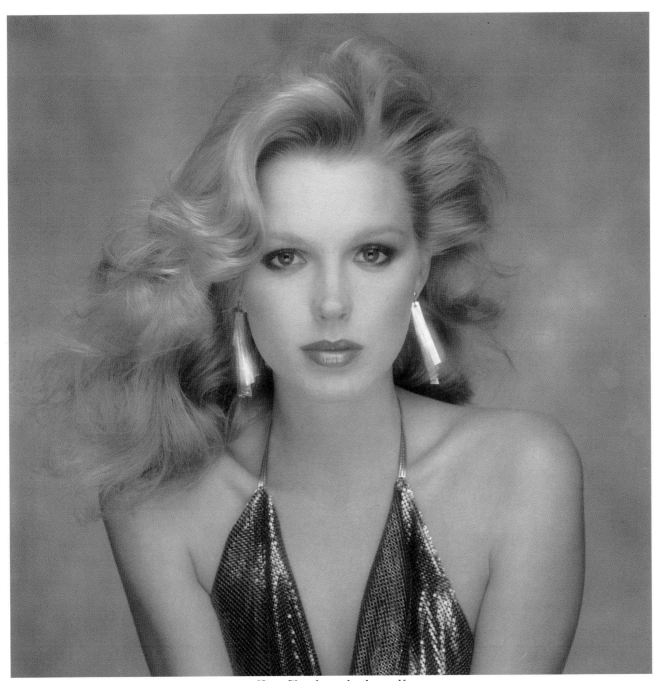

Kim Charlton, for herself.

continually be checked. He can shoot twenty sheets with the Sinar, and the focus will still be accurate.

Gordon Munro is still called on to do a lot of work in black and white. He keeps a strong feeling for black and white. He wants to talk about it.

"Clowns in whiteface—I used them to advertise the Harlequin collection by Borghese at Bloomingdales. Their faces alone make it a beauty shot, and one that works only in black and white. A girl in a white blouse. Her statement is made by her face *and* the clothing, and made very directly by the absence of color."

Sometimes he does portraits in black and white just for his friends. "Barbara and her baby was a gift from me to her. The baby is really hers. When I turned on the fan to blow Barbara's hair, the baby didn't like it and turned its head away. The total effect is that of a still life."

Another friend is a ballerina. When Gordon Munro told her he wanted to shoot her beautiful face, she thought he was kidding.

"It had never occurred to her that she was beautiful. I had to show her the picture to convince her."

If a picture can tell a woman about herself, there must be great artistry in it. The portrait of the ballerina, her face radiating poetry and passion, has to be taken as a work of art.

Gordon Munro sees himself as a commercial photographer. He likes that—and likes what he does. He agrees that when commercial work is done extremely well a line is reached where commerce dissolves into art and it becomes impossible to distinguish the two. He hopes his work is close to that line. He dreams of one day showing in the galleries. He suspects that the great control he exercises, his pursuit of simple but powerful

graphic statements, is the very thing that inhibits him from submitting his work in the world of art.

"I have always felt a barrier that I have not yet broken through. I look forward to a day when my varied attacks will open that door and make me aware of something beyond, toward which I have been slowly moving. I think that's why I shoot only on assignment and not for myself. Because I haven't yet seen that something beyond. I like being given things to do. I find a lot of excitement in solving the problems that come with them. And yet I have the feeling that I'm suddenly going to see something else, and then there won't be enough hours in the day to take everything I will want to take."

It doesn't work for him to set up shots and try weird perspectives. He thinks that whatever it is, it will come right out of his work.

"I like the interaction of things. I spend a lot of time putting things together. Just like in still life—moving this, shifting that. Once everything comes together, I don't shoot that much film. I know I have it."

For Gordon Munro, as he is today, that is where the rush comes—when the composition falls into place, expressing what he has envisioned, summoning up the mood he wants.

"For an instant you capture all those elements that you have been trying to put together. They work well, and they make a statement. What is most exciting is that this statement expresses you. Sometimes it is something new. Then I feel I have taken that extra step and said something that I have never heard before."

95

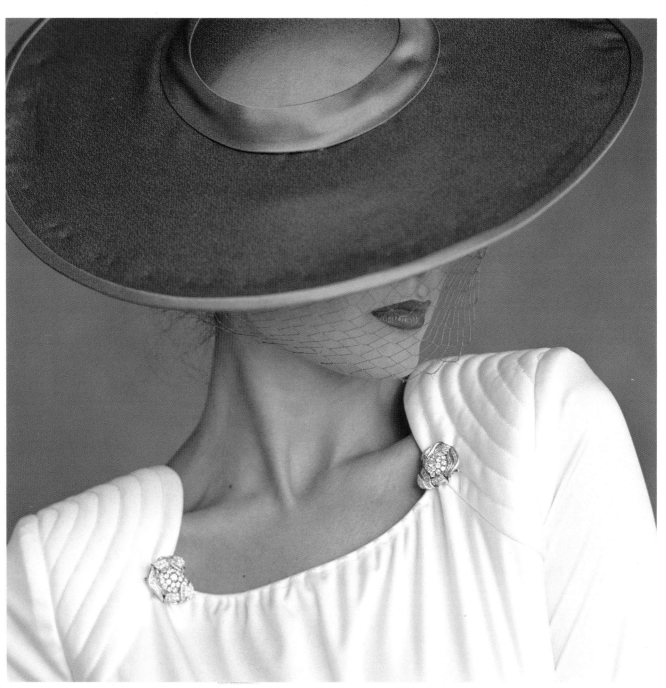

Karen Howard, personal work.

FASHION

Arthur Elgort

Group shot, for Italian *Vogue*. Foreground: Leslie Weiner; left to right: Susan Hess, Lisa Beckley, and Georgio Armani.

Beautiful women strike their poses before the eye of his lens. The women are frames, frameworks, flesh and bone put to the task of displaying what they wear—clothing so stunning as to be unreal. This is a dream world, and Arthur Elgort has given himself the task of making it real.

Movie-making is a similar kind of dream world, where the people involved—directors, cameramen, actors and actresses—find themselves continually on location. They have become nomads, wandering the earth, strangers wherever they are, driven into the tight network of their own intimate society. High-fashion photography is like that. Here Arthur Elgort is the cameraman, yes, but also the director. Primarily the director.

"I think of myself as working the way Ingmar Bergman works. With a repertory company. He did wonderful things because they were a company. His team could take someone like Liv Ullmann, a sensitive, inward woman, and draw astounding performances out of her."

Arthur Elgort has his team. It is made up of an editor, art director, hair stylist, makeup expert, models, merchandisers—and their merchandise, clothing that will set styles on four continents.

"The team transforms the model. It is a transformation into unreality while I work to sustain the reality of the shoot. The editor might be searching for a specific look—easygoing, outdoors, maybe walking on the street somewhere in New York. But the model is wearing a fur coat and it is 100 degrees in the shade. 'We know you can do it,' the editor says. 'We know you will give us what we want.' "

More of the unreality of the high-fashion world. Fur coats must be shot in the blazing summer, to prepare for the sales campaigns in the fall.

Jackie Adams, for *Vogue*.

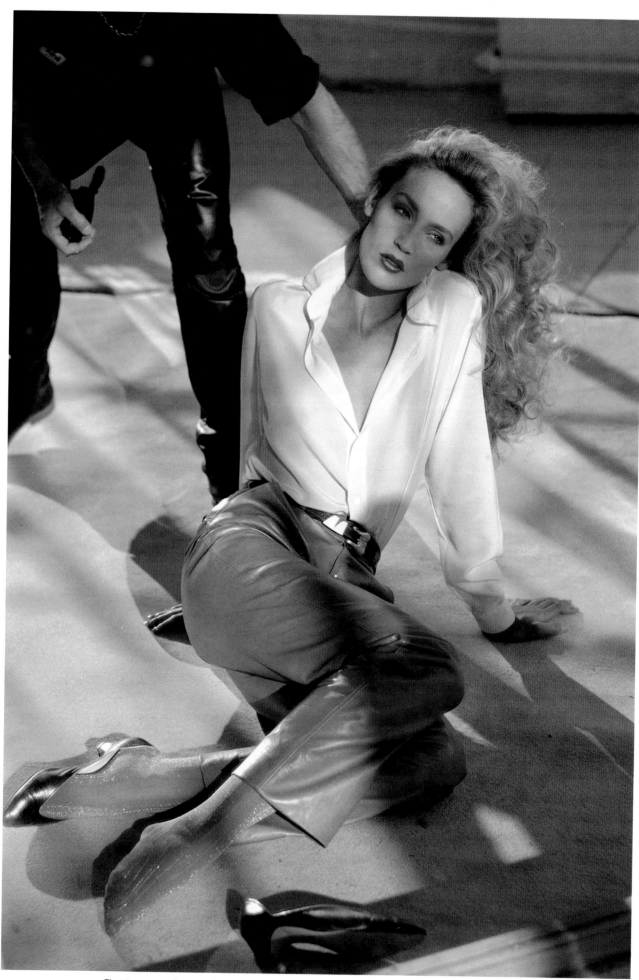

Getting ready . . . for American *Vogue*. Jerry Hall with John Sahag.
Clothes by Roberto di Camerino.

"Out there on the street, you begin to have a performance. The model is an actress. I want her to like what she has on. Her mood will change with the clothes, and at that point, everything begins to depend on how she feels. I am shooting in 35mm. I put on a normal lens so I can move in closer, make contact with her, tell her how marvelous she looks."

Just as in making a movie, the photography, the technical aspects, sink out of sight. If it's out on the street, Arthur Elgort may well be shooting in natural light. He is concentrating on the model's expression, thinking of ways to bring her to life. He wants the results to be real.

"The most interesting thing about fashion photography to me is the whole act of it. I shoot before, during and after the shot that is called for. The model must get ready, must be *made* ready. The preparations are often more real than the actual session. The clothes are on, but the model is not yet completely overcome by them."

Arthur Elgort keeps what he calls these "getting ready" pictures as his personal photographs. He also collects cameras. Photography is his hobby as well as his profession. It would be hard to find a professional more in love with the art and the act of it. Unlike many of his colleagues, he carries a camera wherever he goes.

"In this business, you get typecast. I am expected to be carrying a camera. At the fashion shows I do the runways, whereas Dick Avedon would never do that. I even pack a camera to parties. You would never find Scavullo with his camera at a party."

This means that fashion is not his only subject for shooting. The pictures are on the walls of his apartment on Central Park West in New York City. A bedouin on a camel, ballet dancers—the subjects are varied. They leap off the white walls of his

all-white apartment. The sun streams through the large windows as Arthur Elgort, lounging, looking good in whites, talks about how he got started.

"With ballet dancers at Carnegie Hall. I was working in a restaurant there and got to know them. I was shooting them—and pictures of the neighborhood for the owner of the restaurant. And wondering why I wasn't getting magazine quality with the Polaroid I was using."

He was studying art at Hunter College. One of the teachers knew something about cameras and got Elgort a job photographing art books for William Reuben, who later became painting curator at the Museum of Modern Art. He took the pictures for the Hunter College Yearbook. "A person more practical than myself," he can't remember who, suggested that anyone so crazy about photography should get a job with someone who really knew the business. He went to work first for an advertising illustrator. Then he worked with Gus Peterson, a fashion photographer.

"Peterson was a casual sort of person, easy to get along with. He liked jazz and liked to hang out. He told me I already knew what I wanted to do but just couldn't do it yet. He said it was like my pictures of dancers, caught sort of hanging around—the style would be perfect fashion. He said it would be perfect if I could just capture that snapshot kind of thing."

Arthur Elgort's style began to take shape. The model is outside, in natural light, perhaps standing on a street corner. She looks stunning, and her clothes are marvelous. But she also looks surprised—her face alive, full of expression—as though Arthur Elgort's camera had caught her unawares.

"Back then, working with Peterson, I used to test every morning and every evening, making contacts and prints in the

darkroom. I shot very little color because I didn't have much money. But I made a lot of prints."

Bob Cato at CBS and *McCall's* magazine gave him his first assignment shooting fashion on his own. It turned out that there was room for him in a crowded field.

"Everyone else was doing studio work. No one was into that casual street-corner kind of thing. In those days, anyone who would shoot fashion in natural daylight was a little unusual. Maybe even a little crazy."

Expression and movement—a memory of the ballet dancers at Carnegie Hall. He likes to use models who know how to dance.

"Knowing how to dance creates a certain self-awareness. A certain sense of posture, discipline, breathing. Dancers are good at repeating themselves. A model who knows ballet is lighter, is someone who thinks through what she is doing."

It is a style that is casual yet controlled. It has taken Arthur Elgort to the heights of the intimate world of high fashion: shooting for the *Vogues*, American, French, British and Italian; regular attendance at the openings in Paris, Rome, New York.

"I like it to be sloppy but not sloppy. I'm very much into how people look. If they don't look graceful, beautiful, I don't think they need me. When I shoot for American *Vogue*, I tend to minimalize the background, eliminate the detail, give a feeling of *gros plan*, of a background of pure texture. That's what American *Vogue* likes, something clean, idealized, clear."

The annual showings of new styles are scheduled to create a circuit. One show follows another, pulling the fashion world on its annual trek. Including the fashion photographers.

"Certain people appear on the circuit every year. When I go to Rome this year, I know that in the lobby of the hotel, late at

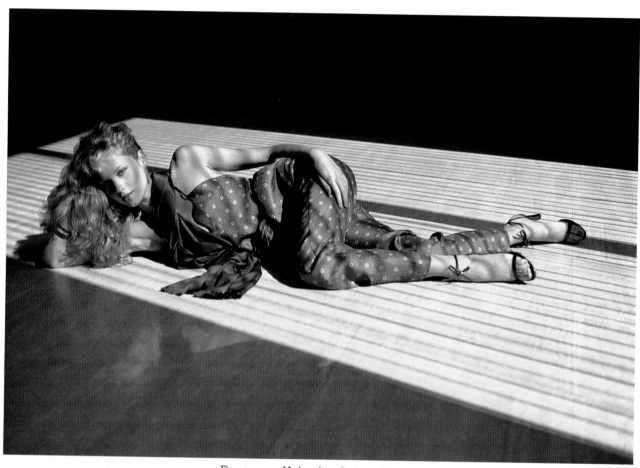

Roseanne Vela, for Calvin Klein.

St. Laurent group studio shot, for American *Vogue*. Left to right:
William Garrett, S. Casey, L. Ryall, J. Foster, and M. Stevens.

night, I will run into David Bailey, Barry Lategan, Patrick De Marchelier. On the circuit every year is where the new girls are going to be seen, where the business is happening. I will shoot the clothes—and sometimes shoot the shows, too. Others don't do that. They are more directors. I am a director—but also an observer. In one issue of a magazine I might have a variety of pictures—runway shots, studio shots, candids of the people in attendance."

The fashion circuit and his work for European magazines keep Arthur Elgort on the move for half of every year. That and his outdoorsy, on-location style—he doesn't want to be encumbered by his own studio. In a domain of photography dominated by studio work, Arthur Elgort is one of the few exceptions.

"I want to keep working for French and Italian *Vogue*. If I had a studio, I would have to take on catalogs to pay the expenses."

With their small circulations, the European *Vogues* cannot pay top prices. But they are experimental, directed toward the business itself, offering an imaginative photographer a chance to do interesting things.

Then, too, the business is international, and Arthur Elgort doesn't want to be anchored. There is that parallel with making movies, that sense of being somewhere that gives flavor to his work. He, too, is in the business of creating stars.

"Alexander Leiberman used to say that he loved the whole Pygmalion aspect of it. Taking some girl from the Middle West and remaking her into the ultimate in sophistication. Here it is like the theater, like ballet, where a fantasy is created. There is a continual, incredible thirst for new faces. The magazines are the showcase in which these new faces are always introduced. Traditionally, the models get their training on the European fashion magazines."

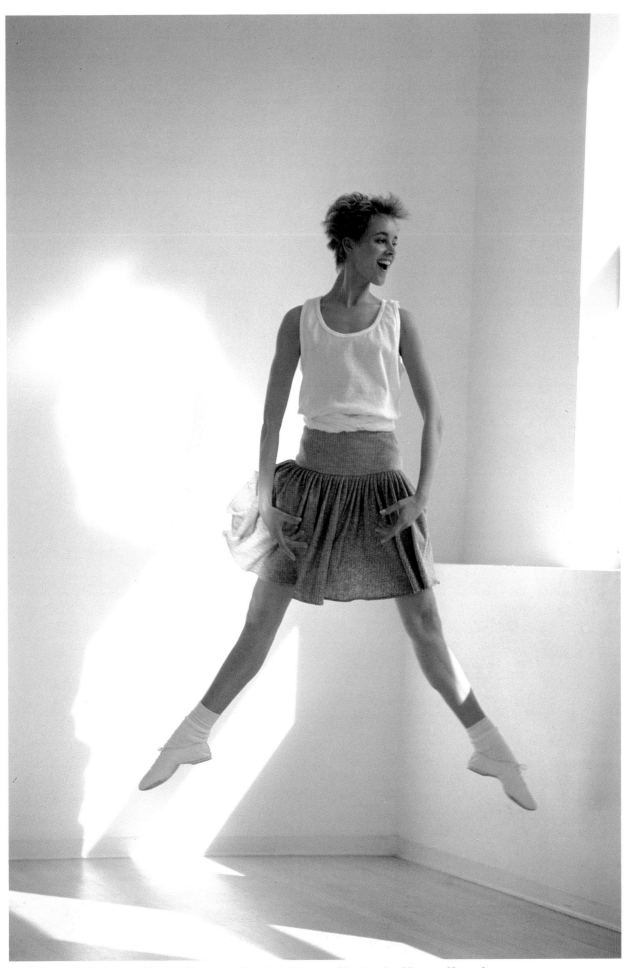

Susan Hess, for English *Vogue*. Clothes by Norma Kamali.

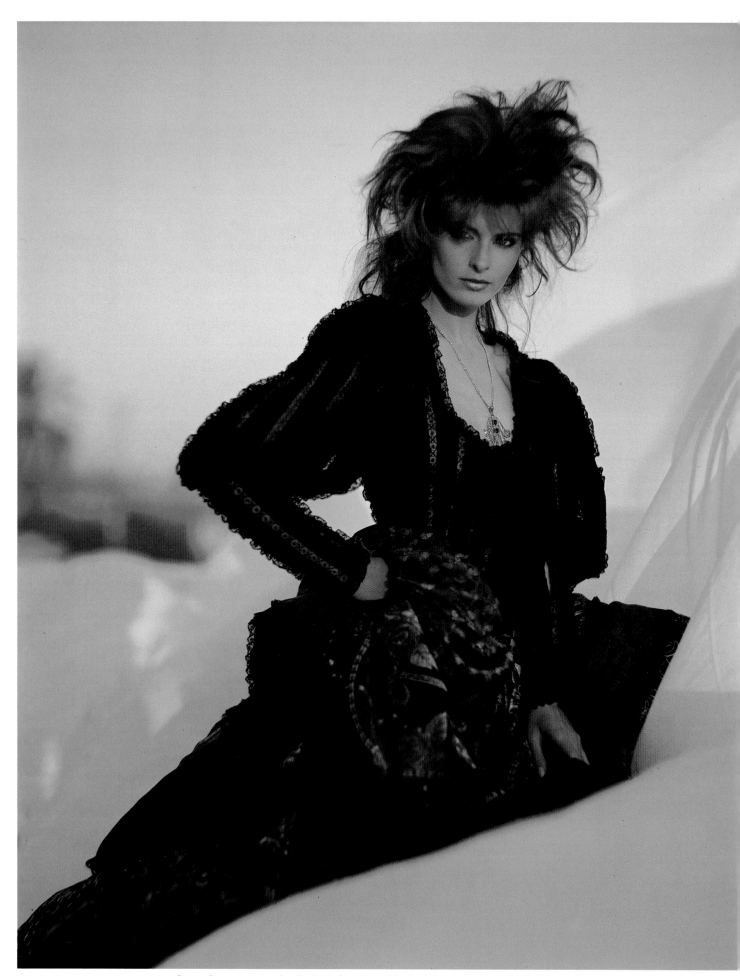

Joan Severance, for Italian *Vogue*. Clothes by Lancetti Collections.

Sometimes the requirements are very specific—a blonde with a fresh American look, a girl big enough to model winter clothes. Someone not easy to find in Europe.

"I've had to take inexperienced models and give them a crash course. Their pictures come out in the fall editions of the European magazines. They are looking good. A place is made for them in America. These are models I have helped introduce."

In such situations, he is playing the part of director *par excellence*. He shows the model what he wants by striking the poses himself. She may become one of his regulars, a member of his "team." She will be someone with whom he makes that magic contact.

If the picture is in color, Arthur Elgort will probably be shooting in 35mm. If it is in black and white, he could be shooting in any format. He will pick a camera from his collection. It might even be a Speed Graphic. He has great affection for the equipment.

"I think it's interesting to see the way the camera leaves its mark on some photographers, how the instrument in a way defines the work."

He uses a metaphor from golf: that he might have a bad long game but a good game close up. He knows that most fashion photographers use long lenses, while he, with his normal lens, will be working in close.

"You get beautiful shots from far away but they don't have that feeling of human contact. My models are used to having me work right next to them when I shoot. When I say 'making contact,' I mean the feeling created is that the model is my friend."

Since she is his friend, he has great concern for her. That her hair be just right, that her makeup be not too hard, that she enjoy the clothes she is modeling.

109

"If the client has specified full-length, I have to get myself into a full-length mood. Perhaps the model will come out in a different mood and I have to bring her around. She may not like the clothes, and I may not like the clothes. If I'm turned off by the whole thing, then I'm in a little bit of trouble."

In such moments, the "team" can save the day. Hairdresser, makeup—the model, too—are all seen by Elgort as creative individuals. They are always experimenting. The model herself may suggest the perfect pose. Somehow they conjure up what is required. They get themselves into the proper mood.

It is the totality of his world that he tries to capture with his "getting ready" shots. Hair and makeup getting the finishing touches, the designer showing how the dress should fall, the assistant holding the lights. Back in art school he was always sketching. These shots are now his sketches. They serve another purpose too. Everyone on the set gets accustomed to his clicking away. When the climax comes and he is shooting for the client, everyone is at ease.

His sense of graphics is instinctive. He doesn't think about graphics. Or if he does, he thinks of it as breaking the space. He tells the model to go in there and break the space. Sitting in his apartment, talking about it, he shows what he means with a picture taken in Italy. Two models and the designer, Armani, in a room framed in dark carved woodwork.

"The picture shows what I think about fashion. It has all the asides going—and the light. 'Well, the light by the window is gorgeous,' I told them. 'We're all going over there.' I had the models where I wanted them, and Armani in the picture, too, and I just walked around that light, getting the whole scene in my lens. This is how I make a statement. I think it is a fashion statement."

He thinks his first pictures were more direct than this, maybe sadder, too, and more funky, more in the neighborhood. When he began, he had a feeling about what he was good at, and he stayed with it. Later on as his style developed, he became much looser, capable of coming at it in a number of ways. When the style hardens, however, he feels he has to move on, try other things. Yet something funky persists. It makes all this fantasy real. It is Arthur Elgort's signature.

"I'm looking for that look where there's a whole kind of moment, where it looks like you just caught it. I want people to look at my pictures and see some sort of distilled reality in them. They know they are fashion pictures, but when they look at them carefully, they still see something real in them. They see that the pictures do not deny reality."

Then of course there is the pure joy of doing it. You ask him what he likes about a shoot, and he will tell you.

"I like to be comfortable and I like to be entertained."

Comfort and entertainment. He gets both with his team, with that group of artists who wander the world to show women what they will be wearing next year.

111

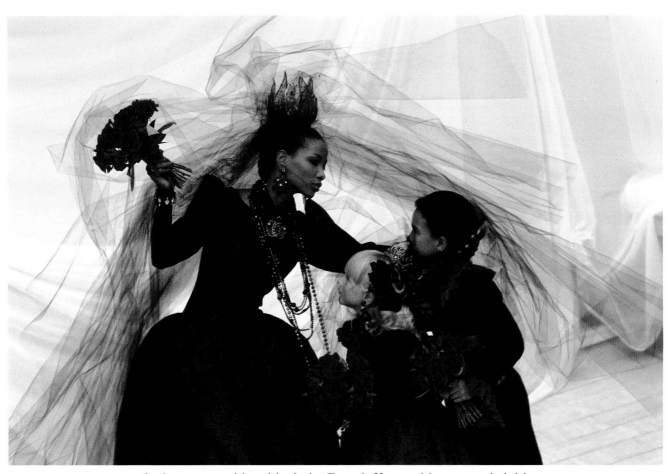

St. Laurent wedding black, for French *Vogue*. Mounia and children.

ANNUAL REPORTS

Burt Glinn

Wisconsin cranberry harvest, for Goldman Sachs.

Corporations are required by law to report annually on their financial condition. Once upon a time that was just what they did. It was in the dark ages—or at least in an age of black and white. To be legible was then accounted the supreme virtue. Always more people seemed to want to see those reports, to run their fingers down the separate columns showing income and expenditures. Corporations were driven to their mimeograph machines. Unfortunately, mimeograph had a way of blurring figures.

The historic moment when a company executive suggested for the first time that the annual report be printed is probably lost beyond recapture. "And maybe we should include a picture of the chairman of the board," he probably said—and timidly, for there was a question in those days as to whether pictures were exactly businesslike.

Since then the world of business, of the great corporations, has come to realize that the annual report can be made into an unmatchable instrument—used for self-promotion, for self-description, for the establishment of an identity, a personality.

Today's corporate annual reports still present the figures on income and expenditures—probably offered in sunbursts of brilliant graphics, contained in a full-color production with a masterful text and marvelous photographs.

If the corporation wants the ultimate in an annual report, it will arrange for Burt Glinn to take those photographs.

He came up through journalism—on *Life* magazine when it was setting the standards of photojournalism. The stamp of high journalism is plain to see in the annual reports he has done for IBM, Seagram, Bristol-Meyers, Warner Communications. Burt Glinn is expensive and concerned about delivering the goods.

"I like to discover the things that are happening—as if I were back on *Life*, and this were a breaking story. The great reports are never those in which people say, 'You just show up and we'll have everything arranged for you.' I like to have a lot to say about what I photograph."

114

What he photographs can be an issue. He deals with companies, with public relations executives who have their own ideas. Sometimes their ideas are excellent. But often, when Burt Glinn is called in, it is because the annual reports have been less than the best. In charge of the report will be some nervous fellow offering tested but trite solutions. "We have to get everything in the picture," he will say. He won't understand that Burt Glinn does get everything in—but often through hints, through implication.

The financial house of Goldman Sachs decided not long ago that their annual reports needed sprucing up. What then happened offers an illustration of how great reports are produced and of how Burt Glinn functions in this complex milieu. As step one, Goldman Sachs called in Arnold Saks, a premium producer of annual reports and designer of corporation brochures.

To the designer, Goldman Sachs explained that they wanted to show people who they were, that they were a big company with important clients. They wanted a handsome report that would show people how they function inside, that would illustrate the kinds of financing they do. None of this flusters Arnold Saks, who is used to doing complicated annual reports. The designer obtains a broad view of the operations at Goldman Sachs. He then calls in Burt Glinn and they go over the operations together. Glinn himself then picks up the story.

"One of the things they do is municipal financing, for example. My response to this was to ask for a list of what they had financed in this category. The list contained a number of projects—low-cost housing in Boston, a hospital in New Orleans. I know that I will not be shooting everything because it would simply be too expensive. I look down the list for what strikes me as offering the best chance to be graphic. With the concurrence of the client, Arnold Saks and I select the hospital in New Orleans.

"This decision involves certain problems. The hospital is a multimillion-dollar client. The people at Goldman Sachs, who do not yet know me, are not sure they want me calling up a multimillion-dollar client to say I want to make arrangements to

California facility, for IBM.

San Francisco office managers, for IBM.

take pictures. The last thing they want is to upset that client.

"This is a delicate situation which has nothing to do with the art of annual reports. Yet it shows how they actually get done. I make arrangements to work with the man in the firm who deals with the hospital. He calls his contact in the hospital, explains what I'm after, and gets the name of the hospital's public relations man. I can then call him and set up a schedule."

So Burt Glinn went to New Orleans to take his pictures. But not all problems had been resolved. Goldman Sachs wanted to use a straight shot of the building they had financed.

"I wanted to use a close-in shot of the surgeon's hands at work, performing an operation. I argued that if the hands are right, the viewer knows there is an expensive building around them. I lost that argument partly—we didn't use the building either. A few years later, however, after Goldman Sachs had come to know me—after we had come to know each other—I would have won the argument."

He lost that argument and won others. The Goldman Sachs report was a stunning production. Burt Glinn showed that despite what some might think, even a financial house offers marvelous photographic opportunities.

"I don't worry about whether I am doing art or not. One thing I know is that it is commerce. It doesn't mean it can't be more than that. But I am in business, and I am expensive. I feel obliged to deliver a product."

He brings to the business his long experience, his great skill, his ability to capture anything—well, practically anything. He won't take an annual report when he doesn't think he can do the best job with it. If the report requires all beauty or all still life, he will stay away from it, "because that's not my shtick." If the report calls for one beauty shot, he will take a crack at it, even though he thinks of it as an expensive gamble.

"When you get an assignment, you get a certain number of problems you have to solve. I try to solve them as best as I can, with as much skill and experience as I can bring to it. I try not to be too facile. This gets to be difficult because you get a lot of the

Heart bypass surgery, for Goldman Sachs.

Cosmos' championship goal, for Warner Communications.

same kind of assignments. Technically, you know how to solve them. My way of trying to escape an easy, slick facility is to try to make things as real as possible."

Burt Glinn uses 35mm for its flexibility. He packs his Nikons with him on assignment, plus many different lenses. His equipment is also a reflection of his journalistic background.

When he began, he went from the Harvard *Crimson* straight to *Life* magazine where he wound up as general assistant and studio manager. After nine months he quit, announcing to the picture editor that he was going to become a photographer. Almost immediately, he had a *Life* cover.

"I had learned a lot in the time I had been in the studio. I worked with Gjon Mili, Ralph Morse, Cornell Capa. Years later, I had to unlearn what I had learned at *Life* as a way of working. They wanted to be sure you got an opener, a closer, a mood picture, a point picture—the last illustrating some specific point."

He went on to work for the Sunday magazine, *This Week*, to become one of the four photographers used regularly by *Holiday* magazine, to become a member of Magnum.

"*Life* magazine was the vehicle by which I became a professional. Magnum was the vehicle by which I learned to see."

He grew up with a whole generation at Magnum—Marc Riboud, Elliott Erwitt, and an exposure to Cartier-Bresson. Erwitt is a favorite of his, as is Erwitt's philosophy: "I like to take pictures, and I particularly like to take pictures that I like."

"It wasn't really graphic design that I learned at Magnum. Graphic design is something else. In photography, it tends to be two-dimensional. In a studio you have a foreground and background and control over what you are doing. The great thing about 'real' photography—and here you can see my prejudices—is that you find yourself facing real chaos, and you make it fall into place against its background. Photographers who are graphic designers tend to simplify things. I like to complicate things—and make the design work."

121

Burt Glinn talked about "a failure" to illustrate what he means by "real." The assignment was to photograph a group of executives at a meeting. Even he admits that it is an assignment that can be deadly. Particularly if the meeting calls for lights. Although he has no trouble in lighting a scene, he sees it as one more element of artificiality.

"The company made a choice of four executives who would constitute a proper balance. There was one very handsome young black, one sort of Mediterranean type, the two others blond and preppy. It just didn't work. It wasn't a real meeting. If you're down on Wall Street in the middle of a decision on whether or not to spend one hundred million dollars, there is a great deal more intensity than when you bring four good-looking executives together to talk about basketball. I would rather have had four ugly executives at a real meeting."

Obviously, Burt Glinn does not maintain a studio. He has access to a studio when he needs one—which is not too often.

"If I can get just the corner of one person and a suggestion of three others, and if something is really happening, then the picture works. If nothing is happening, nothing works."

He sees studio photographers as "inventing" pictures. The results can be marvelous for those who have the temperament for it. But it is not what he does. His temperament, his long experience with breaking stories, have taken him somewhere else. What he does is to "discover" pictures.

"Photography at its very best is to me something that is completely unpredictable. It will make you as honest as an athlete. It's a question of fast reaction time, anticipating what's going to happen, where it will happen."

The Seagram report called for pictures of parties in widely spaced settings that would illustrate Seagram's reach around the world. Burt Glinn arranged for parties in Asia, Africa, and Europe. These were real parties. People were actually consuming Seagram's products. They were having fun. The American party was set up on the tailgate of a station wagon somewhere out in the country. The host is a dog owner. He is pouring a

122

Ship in drydock in Hamburg, West Germany, for Xerox.

drink for someone. A little smoke is rising. Suddenly people and dogs fall into place. The scene composes itself.

"A shot like that falls into place just once. You can't control those things. You can only *recognize* them. A photographer interested purely in design would have placed the people where he wanted them. But the shot works as it is—and partly because it is not exactly perfect. Life is not perfect."

Burt Glinn was commissioned to do five brochures for IBM. They called for photographs to be taken all over the United States—in Atlanta, Chicago, San Francisco. As a mark of his professionalism, of the way he delivers, he finished the assignment within ten days.

IBM is interested in the architecture of its buildings, and he knew he would have to get a photograph of the company's handsome structure in San Jose, California. A connecting corridor with deep windows offered an interesting graphic design. To bring it off, Burt Glinn had to do some "inventing."

"Nothing was happening. I asked two of the people who were with me to go stand in the upper windows and talk. They had to go way around to get there, and just as they arrived, two other people—completely by chance—stopped to talk in the lower windows."

In the end, it was the two couples, above and below, who made the picture really work. Burt Glinn agrees that sometimes he has to invent the situation, but with an invention which allows the greatest possible amount of freedom. Within that invented situation, he still has to "recognize" the picture. In contrast to the studied graphics of the San Jose building, the IBM brochures contain grab shots, a burst of flowers outside the window of the office in Atlanta, something else spotted in the pressure of the moment.

Research is required to reveal the photographic possibilities that a corporation offers, and Burt Glinn will hire researchers to find out for him what he needs to know. For Seagram, research led him to a marvelous plantation of maguey cactus in Mexico, from which the company extracts its tequila. It took him

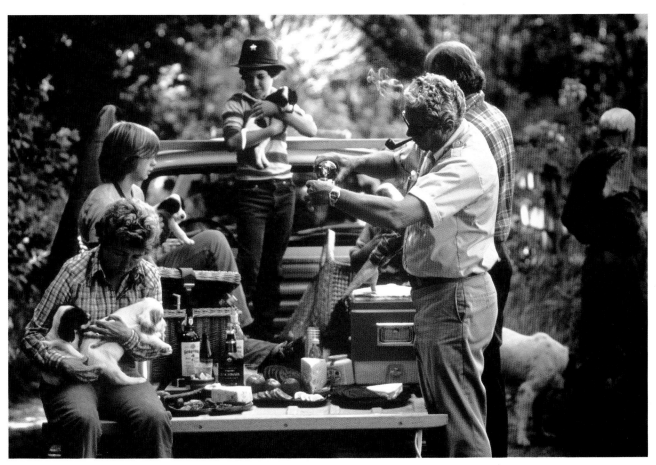

Tailgate party, for Seagram.

to the brilliant red of a cranberry harvest financed by Goldman Sachs. Learning that Warner Communications sponsors the Cosmos soccer team, he used the occasion of the team's kicking a winning goal to vividly illustrate the company. Warners produces sheet music, and he showed this sheet music in use, as a part of real life, in the parade of a high school band.

Still other help is sometimes required for what he wants to do. A photograph might involve sixteen joggers in Central Park in the dead of winter—with releases signed by each. It might be a complicated shot of chefs in a kitchen and a table covered with elaborate confections.

"Most photographers use stylists to help them put these things together. I do also, but my stylist is more of a casting director. She is Karen Vaughan and she lives in Little Compton, Rhode Island, where she knows everybody and everything within a hundred-mile radius. I try almost never to use professional models. I prefer to use real people and real things in real locations. Karen excels at getting all that together."

Bristol-Myers, for whom Burt Glinn has worked eight years in a row, puts out a two-part annual report, the first part showing the company's activities, the second an essay on a health or social problem in which the company has an interest. Burt Glinn has done four of these essays—on such subjects as cancer research or clinical nutrition. What will make successful illustrations of such abstract subjects? A lot of research is needed to answer that question.

"The pleasure in doing the Bristol-Myers annual report comes from the fact that the shape it takes follows from what I am able to find out."

It sometimes happens that Burt Glinn will end up instructing a company about its own operations. Executives will look at the pictures he has taken for their annual report and say, "Good lord, is that what we do? Is that us? I never realized."

More often he has to provide instruction that will rid executives, editors, and the public in general of their misconceptions, as he perceives them, of the role and function of photographic illus-

trations. First is the misconception that the picture should say that the photographer, the company, the magazine "was there." Some of Burt Glinn's greatest successes came from going somewhere else, from finding a unique perspective, or the part of the story that no one else is covering.

"I learned to go always in the opposite direction from where the other photographers were headed."

The second misconception is that the photograph should illustrate the text. In Burt Glinn's view, the photographs should amplify the text.

"If the photograph and the words say the same thing, then someone has wasted some effort."

He has gone on extended magazine assignments without ever seeing the writer. Only once in a great while, as he reports it, has this caused a problem. On one occasion he submitted photographs showing the magic of Montmartre in Paris, when Joseph Wechsberg, the writer, was saying that the magic had vanished.

As Burt Glinn sees it, the instincts of the photographer and the writer are exactly opposite.

"Writing is linear. One sentence, one thought, flows from another. A photograph explodes on you. It surrounds you. Everything it has, it offers simultaneously. You should be able to smell the place from the photograph."

Sights, smells, the flavor of real life.

"When a picture is graphically perfect, it is imperfect as far as I am concerned. When the design is too orderly, it ceases to represent life. It is no longer believable."

For Burt Glinn, the most important thing in a picture is its *emotional* design. Always he is in pursuit of that elusive reality, of that complicated simplicity so difficult to achieve. He wants his pictures to summon up the emotions shared by people who live in the real world.

Log mover, for Scott Paper.

INTERIORS

Jaime Ardiles-Arce

Employees' lunchroom in the offices of a major U.S. corporation.

He would meet and talk anywhere as long as he liked the room, the space. It couldn't be in his studio, since he has none. Or rather, his studio is the entire inhabited world, all those interior spaces in which people spend most of their time.

On this occasion, he would meet in a New York hotel, one of his favorites, and there explain his photographs, explain himself. The room was dignified, but not overly exciting. Jaime Ardiles-Arce surveyed it with his practiced eye.

"I would never photograph it as it is. I would transform a thousand things. Paradoxically, it would still be the same room, the same interior design, and yet it would become fabulous. What I photograph is the truth, and yet it is an embellished truth."

To Ardiles-Arce, an interior is an offering of endless possibilities. The room, framed in his viewing screen, will still be the room, never anything else. But before he takes the picture, he will have added flowers, cleaned off a table, shifted the chairs, adjusted the cushions, or done any other of his "thousand things."

"I try to get into the spirit of the room, find what makes it unique. I want to interpret the spaces I photograph in ways that make them *welcoming*. They are *social*. I have them all dressed up, ready to receive someone."

Under his lens, for example, a bedroom becomes a paradise. The bed is at a distance, sparkling with gold, irresistible in its invitation within the arched frame of a potted tree. Coffee and flowers extend a welcome. A book on a table shows that someone lives in this room.

"This someone is a woman. The little props on the table, all very soft and womanly, were not there to begin with. The bed is inviting with its soft curves. The lighting is mellow, very soft, with no harsh shadows. It is not an objective photograph. It is an interpretation of the room."

130

A bedroom on Fifth Avenue, New York City.

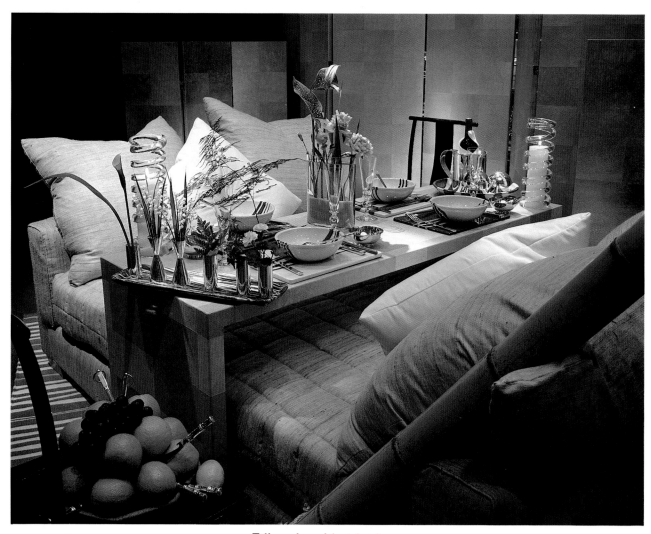

Tiffany breakfast for four.

It is a bedroom shown to be erotic—without a single person in it. But rooms themselves have their personalities and passions as Ardiles-Arce sees them. A small private space might be feminine, secretive, mysterious. Large public spaces are often brazen and masculine. These he may light brilliantly, revealing everything.

Jaime Ardiles-Arce, the son of a diplomat, was raised in a beautiful Spanish-style house in La Paz, Bolivia. With its hand-carved furniture, its handsome rugs, his home offered him his first chance to get a feeling for fine interiors. Yet his impulse was to become an architect, a profession that places its central emphasis on exteriors. As an architect, he worked with the top professionals, with some years spent in Marcel Breuer's office.

"I got into interiors by accident. I had had an accident—which made it painful to sit at a drafting table. One day I ran into a friend who was on an assignment photographing interiors. I went along with him."

He was already photographing—shooting exteriors, as might have been expected of an architect. With the camera, he is entirely self-taught. He confesses that he learned the art by reading Kodak's how-to books. He shoots an occasional exterior, but finds it frustrating as a full-time occupation.

"By nature I'm just too impatient. I felt a need to wait until the light was correct for me—until waiting drove me out of my mind. Suddenly, the light would be perfect, and I would set up, and then it would be gone. The clouds would have moved in, and I would have to wait for hours for the shadows to pass. Once I wanted sunlight just to skim over a highly textured wall so that the stone would become almost tactile, as if it were a fabric. I put out the equipment, but it was too late—the light was gone. I waited for the next day—and it turned out to be cloudy. It was then I decided that I was going to move inside."

133

He has a strong feeling for natural light, for both the diffused north light that is good for people and "the sunlight that can be marvelous at times, for the hard shadows of southern light." With interiors, you almost always have to light them yourself. Still, as he said: "You can do things with interiors that you can't do with exteriors. Inside, you can work with everything the room holds."

It isn't that interiors don't make their own demands—for patience, among other virtues. It is not unusual for Ardiles-Arce to spend as long as five hours getting one shot. The room itself must be made to speak, to express its personality. The lights must be selected and placed properly.

"I almost always put lights into the picture. I almost never run into an interior in which the lighting is already what I want. It's very much a part of me to bring out color contrasts with the lighting. To play with the chiaroscuro of light against dark. You get to know how walls will reflect different kinds of lights. My lighting is my signature. Other people, too, can look at my pictures and tell instantly that I took them."

He uses electronic flash often, especially during the daytime. And quartz lights, which are warm, to go with incandescents. Sometimes he reverses this, or even mixes the lights, spending hours getting just the effect he wants. Reaching for the perfect balance. Often this means that the lighting seems to vanish. You look at the picture and you can't tell where the lights were placed. He shoots a discotheque in Chicago, and the result is a masterpiece of lighting.

"It was a very large space with its own lights, arranged in a great variety of colors. I wanted to emphasize the way the dome floats above it all. To show the lighting on the dance floor, which is going darker at the edges. To give glimpses into the other rooms so that you can see that one is a bar, another something else.

"I had to keep the colors true to show the festive intention of this great space. Here you dance, you drink, you get high. The lighting summons up the personality of the room—a dreamy place, psychedelic, full of feeling."

For the picture itself, he will use a view camera, with its various tilts and swerves, capable of manipulating interior lines. And once in a while, the interior is captured while using only daylight, as in a bank in Houston.

"In the bank, the lines are clear and strong although the overall effect is soft. A large space, filled with clarity of day. I had to remember that it is a bank, a place of business—with no place in it for dark little corners. The room makes a statement, but it is the opposite of what I often try to capture in residential interiors, where the mood can be suggestive and sensual, mysterious and elegant at the same time."

These are pictures that lure the viewer, entice him inside, into rooms whose statements are expressed in beautifully subtle ways. Jaime Ardiles-Arce may have learned subtlety from a father in the foreign service of his country. He used to listen to his father at work, "convincing others," as he put it, "precisely because he was subtle." In his strange way, a small living room might be turned by Ardiles-Arce's artistry into a portrait of its owner, of the woman who lives in that room.

"The paintings offer a hint of what she is like. The table surface sparkles with a kind of festive gaiety. The red flowers are a burst of lipstick. Soft shapes are almost like breasts. The glasses are jewels, glittering like a diamond necklace. I often try to get this with residential interiors—a sexual, sensual presence that parallels the person."

Some interiors constitute technical problems of almost overwhelming complexity. When you see what Ardiles-Arce does with them, you can't believe he didn't learn his art—or his

135

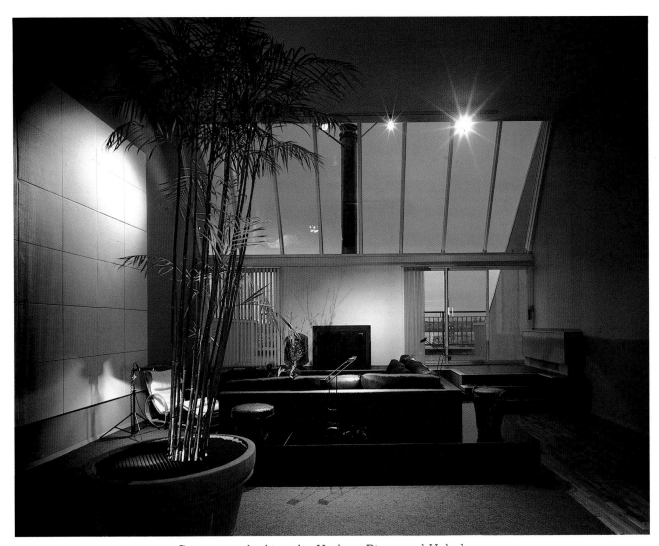

Sunset overlooking the Hudson River and Hoboken.

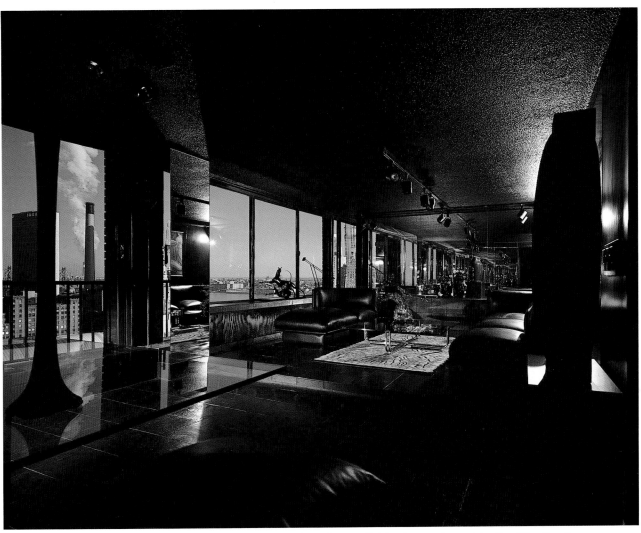

The ultimate daring, exquisitely rendered: an all-black apartment in the Big Apple.

tricks—from another master. This was the case with a New York apartment decorated in black with one mirror wall and another wall made of windows through which daylight streamed, and a brilliant view of the city. The dark interior makes a contrast with the brightness of the outside.

"How to illuminate that situation—well, it was incredibly difficult. Black walls, black ceiling, black cushions—you can see they are black, and at the same time you can see outside, where the East River and the United Nations are washed in sunlight. I played with the lights to add brilliance to the ceiling, to bring out its tactile qualities. And yet there is not a trace in the picture of where my lights are. Not a trace."

The room has become a skyscraper cave, fronting on the brilliance of the metropolis. One view of this room looks out squarely on the skyscrapers of midtown, the exterior dominating the interior, but as if it were a mural painted on the wall. Interiors were not always photographed with such flair. The idea that rooms might speak as vividly as those who live or work in them, that they might even present a chronicle of their inhabitants—there are those who say that this was Jaime Ardiles-Arce's original invention.

"When I started to take interiors—well, I must say that my approach affected many people as something new. The usual thing—you could see it in all the magazines—was even illumination, everything very obvious, and a bouquet of flowers for romance."

Ardiles-Arce calls that "shooting from the door." The photographer opens the door, which will often be in a corner, looks into the room from that corner, backs up a little bit to get it all in, and takes his shot from there.

"Of course, he will have set up his lights. A flat light, giving a luminous ceiling without shadows, where you can tell precisely

where everything is. It's almost like industrial photography, where you're trying to sell, say, the furniture."

Jaime Ardiles-Arce is of course selling something too, as he sometimes has to remind himself.

"For me one of the important things is that people get pleasure out of seeing my photographs. But I have to remember that I am a businessman, too. That the people who hire me are also in business. That my pictures are often sales tools for designers. What I sell is glamour."

But then he has other clients as well—people who want their homes or offices rendered the way Ardiles-Arce does them. Who ask for nothing more than the pleasure of looking at his photographs.

He is very clear about what he is doing, and has been ever since he began—only eight years ago. While he was still work-ing as an architect, he felt there was something missing in the way interiors were then being photographed.

"I was sure there was another dimension to it. I felt I could catch more than what I was seeing in all those magazines. I felt there was a way in which an interior could catch a lifestyle. When I began, I had that in mind. I didn't fall into it by mistake. It was what I set out to do from the beginning."

A lifestyle. He shows what he means with a photograph of an office, of what is basically a simple room. Ardiles-Arce has organized its elements, and every element says something.

"There is very little on the desk—an in-tray and an out-tray, and pencils for dashing off memos. This is the office of the chairman of the board, and he needs nothing else. A classy, sophisticated ashtray tells you something else about the man. The skyscraper seen through the window lets you know that this office is in the heart of a big city."

A desk, a chair, a window. An office re-created, reduced to its solar essence. Ardiles-Arce will often add elements, but in the office he has taken them away. He is in pursuit of more than reality, "of the soul," as he says, "the spirit of the place, of what goes beyond reality." The office was photographed at the edge of night, at the last moment of the sunset.

He has a special feeling for sunsets, for interiors taken at sunset. That long-waning time of day is to him the most beautiful. Guests arrive, cocktails are served, and everyone appears, dressed for dinner, ready for the theater, the opera.

"It is a moment of magic. The windows of a room will show the glitter of the day's end. And the room itself is all dressed up, just like the people who will soon be filling it. It is waiting for them, inviting and expectant."

But the people are not yet there. In Ardiles-Arce's interiors, people are seldom present.

"I might find in a room a little frame holding the photograph of a child, a very meaningful thing for a room. So I compose the picture and place the frame so that it will be part of the composition of that room. To the person viewing it, the photograph of the child will read 'family.' "

A photograph of the child, but rarely the child itself. The rooms wait, displaying themselves, showing off. They are expecting people at any moment. They want people, they yearn to be filled. But the people will come later. After all, if people were there, they would do the talking. The rooms would fall silent.

When these rooms first spoke, when they were first brought to life by Ardiles-Arce, they went off like thunder in the quiet world of interior photography. He had been at it for less than a year when he was contacted by Kodak for an interview. Polaroid asked him to test their new 8 × 10 sheets in his style. Soon he was featured everywhere, in interviews and articles published both at home and abroad. Interior photography was

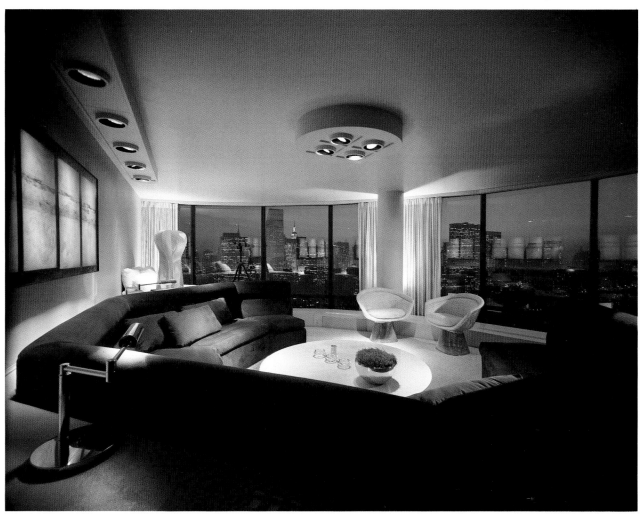

We live for you, New York!

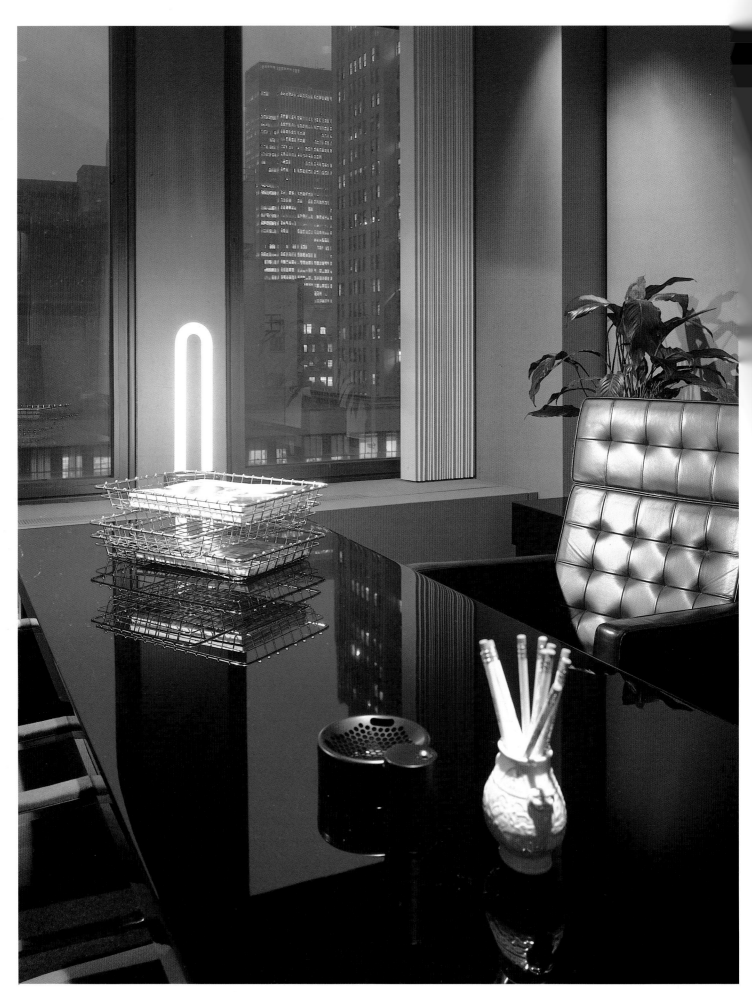

Corner office of climbing young executive.

transformed. Ardiles-Arce had supplied a revelation. Everyone began to shoot interiors in his style—or try to.

"When I studied architecture, I played with proportions, with themes of balance, with what one could do with lines. Yet properly speaking, I know nothing of formal graphic design. My approach is purely intuitive."

That may be, and yet Ardiles-Arce has had a profound impact on the interior designers he works with. Sometimes they will alter an interior to make it look more like his photograph. Seated in a hotel room in New York City, in a room in which he would "change a thousand things," he thinks back and recalls an example. He was photographing a restaurant in Texas.

"I put some lights in, carefully placed to create some marvelous shadows, to break up a flat ceiling. Afterward, the designer proceeded to paint the ceiling with the same shadows. Now the ceiling looks like a forest."

The people are not there, and yet they are—in the mood, in the manner of presentation. Even the placement of a pillow can be crucial.

"Mood is more important than anything else. It emerges out of shapes—and in the gradation from one shape to another. In the play of reflections. A plant is placed in a table setting. Its leaves appear, disappear, and reappear as the light cuts across them to illuminate just the table's edge."

In each shot, as he says, "worlds are being arranged." Composition, balance, and sparkle—these are still lifes of great habitations, already beautiful and made more so. What Jaime Ardiles-Arce cannot get over is that these are not stage sets. They are homes, offices, places where people actually gather, spaces that are not divorced from life. "People actually live in these rooms," he said, and then asked, "Can you imagine that?"

143

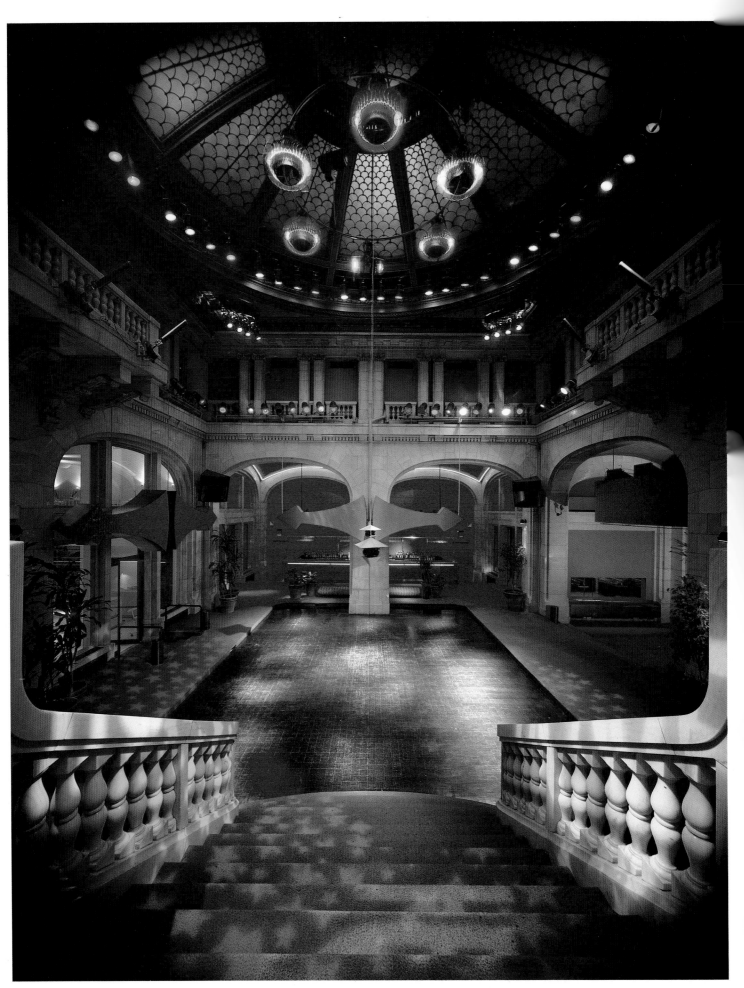

Chicago discotheque, minutes before the rush.

SETTINGS

Cheyco Leidmann

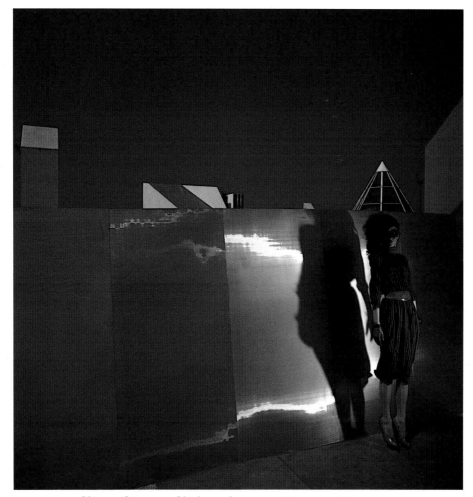

Client: Comma Clothes; Agency: Ulmann, Düsseldorf;
Art Director: Karl Ulmann.

A contract to do a calendar for BMW becomes a world tour. Cheyco Leidmann wants to show these cars themselves seeing the world. No driver is in view, no passengers. These clean sedans might have posed all by themselves against their staggering backdrops. But of course it is Cheyco Leidmann who has put them there.

"The selection of the setting is all-important. I cannot leave that to anyone else. I must choose the setting myself."

These are the opposite of the automobile ads that Americans are used to seeing. The glittering vehicle, icon of the age, no longer fills the frame. The BMWs are microscopic in the immensity of overpowering landscapes, yet still the center of attention. The viewer thinks, "I could buy that car. *And drive it to that very place!*"

But it would not be as easy as all that. To produce this calendar meant for Cheyco Leidmann and his team a journey of 12,000 km carried out in four weeks—to Corsica, the Sahara, Iceland. Temperatures in the desert hit 120°. In Iceland, the cars got stuck in the mud. An incoming tide by the edge of the sea meant the cars had to be hauled out by tow truck. For Cheyco Leidmann, the perfect setting is worth overcoming every obstacle. In one place, a car was demolished in an avalanche.

"Every shot is for me an experience. To find my ideas, I need music. From the moment I put on my headphones I begin to concentrate."

Cheyco Leidmann sees his photographs as "motives." What he wants to do is display his inner experience, show what he felt by showing a photograph. He wants people to see the photograph and feel the same thing he felt.

"Communication without words. I want to transmit a feeling without explaining anything. I want people to understand me without imposing on them a concept of the world."

Cheyco Leidmann was born and raised in a village in the Black Forest. He would have become a painter if his talents had run that way. He developed an ambition to make movies—until he realized that in Germany, the number of great working film directors could be counted on the fingers of one hand. Whatever he would do, it would be in the visual arts.

"I am a visual person. But then most people are visual, aren't they? It's because of that that I am able to communicate."

In 1976, at the age of twenty-five, Cheyco Leidmann established himself as a professional photographer in Paris. Without a studio—since he prefers locations. And working in all formats—Nikon for 35mm, Hasselblad for 2¼, Linhof for large format—whatever he feels the situation requires.

"Not that I would ever want to talk about photography. I am not interested in photography. I don't even believe in it."

A strange thing for a photographer to say. But one can understand what Leidmann means. Exposures and *f*-stops are never for him the interesting aspects of a picture. They are the mechanical elements of it, the aspects that must be surmounted before the picture begins to take shape. He has gone through all that, to come out on the other side.

"I would have to say that I am essentially self-taught. I had no formal training in graphics—or in photography."

He tells his story in his excellent English while remarking that he is "not a verbal sort of person." Like other professional pho-

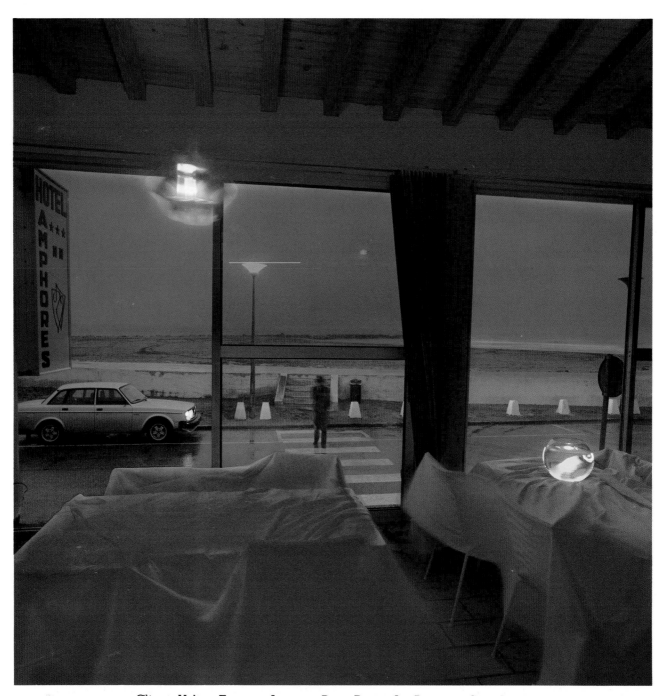

Client: Volvo, France; Agency: Dire, Paris; Art Director: Stan Levy.

tographers, he went through an apprenticeship in endless hours of testing, testing. Having put himself through the process, he resists classification.

"I suppose you could say there is a 'European' way of shooting. But I don't think you could necessarily include me in it."

Looking at his pictures, you would have to agree—there is no one quite like Cheyco Leidmann. On the technical side that he would rather not talk about, his photographic style shows an element that leaps forth with stunning impact. Cheyco Leidmann has made himself a master of filtration. As with others, his apprenticeship was spent in solving problems of lighting and exposure, to which he added a detailed investigation of filters.

"I didn't have the natural talent to become a painter. But I discovered I could paint with filters."

The result can be seen in his stunning colors. Cheyco Leidmann's pictures are saturated with color. In an interview given in Majorca to a Japanese reporter, Goro Nishimaru, Leidmann said: "Color cannot be disregarded in our vision of the world. Its psychological impact is tremendous. To my mind, color offers enormous expressive potential. It can bring a shock to the consciousness of the onlooker. This is of the utmost importance. To say that impact is reduced or diluted by color is incomprehensible. Such assertions are sheer nonsense."

In the same interview, he explained his technique. "Of course, color cannot function without light. It is revealed by light. To speak in a truly photographic sense, it is the light-sensitive surface on which I center my attention—to the point of ignoring the camera, the tool.

"Outside the studio and its artificial lighting, landscape and townscape offer the maximum range of luminosity thanks to the infinite, dynamic light which comes from the sky. Of course, you cannot reach out and shift this light. But it can be manipulated through the use of filters and by artificial lighting effects. You strive to create a 'revelation' through light in which the eye is first attracted to the lightest parts of the picture only to be guided away from them afterward. I use this fact consciously as a method of composition."

Light—and shadow, too. Cheyco Leidmann could write a book about shadow. The shadow of a person, gesticulating, protesting, spreads over the sand surface and completes the composition of a picture made for Landlubber Jeans.

This is a picture that displays a number of Leidmann's many artifices. Gold-brown sand is grained like wood and separated from a sky of incredibly deep blue by the shining line of the horizon. The model, her back turned to the viewer, is cut off top and bottom to center attention on the erotic curves of her flaming red jeans. Far away and to the right, an American flag rises from the sand to ripple like metal. This flag was inserted into the picture later.

In the upper left against the sky, water erupts from a glass suspended in space. This glass was not added to the picture later. It was tossed into the shot by an assistant. Since water and glass had to fit perfectly into the composition, the shot had to be taken again and again. But every time the glass landed, it made a wet mark in the sand. So the whole scene had to be moved a few feet forward for each successive take.

Typically, this was a picture made on location—in this case, Grand Canary Island. Leidmann went there accompanied by

Client: BMW, Munich; Agency: Sortive Werbung Munchen; Art Director: Helmut Mätzler.

Client: Landlubber Jeans, M. Hoffmann, Boston; Agency: SPW Zurich.

Client: Landlubber Jeans, M. Hoffmann, Boston; Agency: SPW Zurich.

what he calls "my team." These are people who are used to working with him, who understand and respond to his particular needs.

"I will improvise in the course of shooting, trying anything that comes to me—or whatever is called for by the codes of my inner experience. The pictures themselves are not improvised in the sense that much care and long preparation have gone into them. Yet once the setting is established, I feel a need to bring the pictures to life. I let the inspiration of the moment direct me to create that symbolic force I want to unleash on the viewer."

To get what he wants, Cheyco Leidmann will use any and every technique available. There would be no use in arguing with him about a philosophy of "pure" photography, about the virtues of unretouched negatives or whatever else the concept of "pure" might contain.

"And yet photography is philosophy. I express my philosophy in my pictures. It is that part of philosophy they call aesthetics."

A strange aesthetics to those accustomed to straightforward advertising presentations. The word "surreal" leaps to mind. Bit-Bier, a German brand of beer, was photographed on a roof-top on Grand Canary Island. Walls and floor were painted white to show off the shadow of the waiter, to display the colors of his transparent tray. No customer can be seen here smacking his lips. But that beer is waiting for someone, a glass of it on a blue glass tabletop beneath its perfect crown of foam. Here again the setting is everything.

And yet not everything. For somehow, in these overpowering settings, the object, too, is featured.

"It could be anything, that object—a car, a piece of clothing, a glass of beer. You have to fall in love with it if you want to draw

Client: Bit-Bier; Agency: Facta Köln with SPW Zurich.

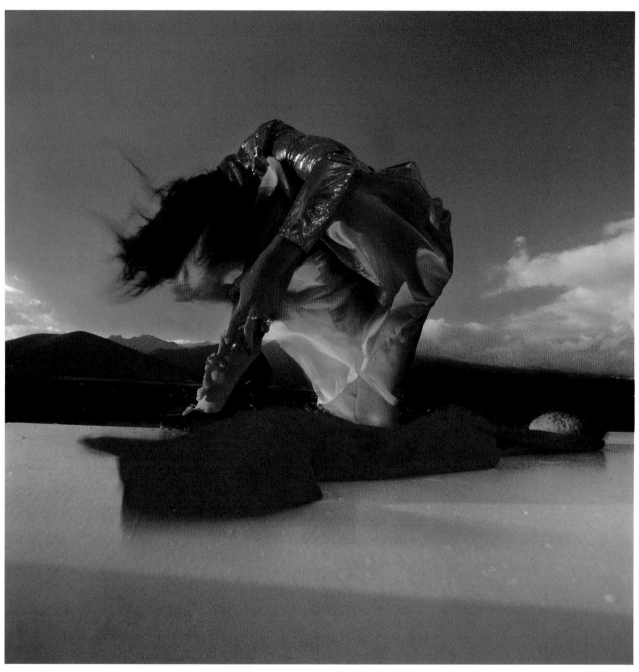

Photograph for 1982 calendar. Client: Pierre Borris Creation; Agency: Atlas-Copco, Paris.

forth its essence. It might be a pair of scissors, or any other object from everyday life. You have to fall in love with those scissors if you hope to lift them into a heightened kind of reality. And you can. You can fall in love with them."

Or the object might be a bottle of Polysoft hair conditioner. In this case, the object has been transformed, reproduced six feet tall, open at the back so that lights could be installed inside. On a rocky beach in Brittany, the bottle becomes a monument, poised on the horizon, brilliantly illuminated. A housetop peeks over the edge of this world. In her polyester jumpsuit, the model stands alone in the foreground, isolated, her face in shadow and her hair full of light.

A woman isolated in an eerie world is almost a Leidmann trademark. She is there to express the message of the object. Other objects are added to the picture—a housetop, a jetliner passing overhead, an American flag, a flying glass of water. The identifiable flying object is another Leidmann trademark.

"No object can ever be defined. It becomes what it is in the setting, in the hidden drama in which the isolated woman takes her position. The objects added to the picture seem to have nothing to do with this woman. Yet they elaborate the drama in which she is the chief character. In unfamiliar settings, the trivial objects of everyday life establish an emotional tension."

With Cheyco Leidmann, no rule ever applies for all time. The woman herself can become the flying object. For Playboy's Christmas showing of irresistible merchandise, he played with this theme: The items are so attractive that one could not resist stealing them. Here is Leidmann shooting in a studio, developing his theme in red and black. Like other thieves, the models

157

wear black gloves and refuse to show their faces. One of them is flying through a window packing a Sony TV set. Naturally the TV is on—showing a scene from "Gunsmoke."

Or the flying object is a skier. Of course he is in red against the deep blue of the mountain sky. The models make a contrast to the skier's dynamics. They stand in the snow like twin columns, clad in Fusalp ski clothes. Even on the crest of the Alps, color is everything.

Or again on location, close to sea level, the model stands beside a wall of ice, or of a set that shines blue-white like ice. She is in Comma clothes, everything in rich, saturated red, shoes and gloves too. Dark glasses and flying black hair emphasize the aura of white light in which she is framed.

"The world is composed of colors. The truth of the world is in its color. It is a physical phenomenon with unlimited possibilities for expression. Color can strike the viewer like an avalanche."

The saturation, and a sparing use of light, give a dark cast to much of Cheyco Leidmann's work. He likes night scenes, but even daylight can take on a sinister tone in his pictures. His daylit landscapes become abusive, threatening. The symbolic force that he unleashes on the viewer is composed in the language of that inner code. As he said in his interview with Nishimaru:

"My life is made up of events that I have translated into a set of personal codes. The code reappears in the photographs. It is by means of the code that I hope to inspire drama and terror, and all the power of the human imagination."

Wordless communication, as Leidmann puts it, and yet each picture is a moment in a drama. A five-act play could be written around each one, placing it in the endless context of life.

Each one, too, is perfectly framed, an aspect that he considers to be "technical" and therefore the uninteresting part of photography. Any of his pictures can be turned any way—upside down or on its side—and the design and structure will hold. Yet for Cheyco Leidmann that is the least of it. What matters is how the eye is led into the shot, directed first here, then there.

"What is 'technique'? It is a way of seeing new relations between human bodies and inanimate objects."

In itself, photography is not an art form. And yet art can be created by the camera, the photographic tool. There is a difference as Leidmann perceives it.

"Art is the unveiling of a new kind of consciousness. An art like painting does that all the time. The art of photography depends on capturing a new visualization of objects, of people in a universe of objects. As such, photography is closer to life than it is to any other art."

There is almost a contradiction in that. Perhaps it is this contradiction that gives Cheyco Leidmann's photography its explosive force. If this is life that he has captured, it is life transfigured, the unconscious made manifest, the forces beneath the surface brought out and displayed in an almost unbearable interplay of light and shadow.

Client: Revillon perfume, Paris; Agency: Interpromotion Paris; Art Director: Eduard Nicola.

THE TECHNIQUE OF
ADVERTISING PHOTOGRAPHY

Photograph by Brian D. Mercer.

Reid Miles works with his actors, subjects, and models. He has the overall concept of the shot well planned before he starts, and then strives to obtain the perfect performance from the people in front of his camera. Once the complex set is designed and built, and the lights positioned, it is a matter of eliciting the best possible expressions from the actors, which provide the focus for the elaborate construction.

Reid Miles likes to work with a 35mm camera and a slightly long lens. The small camera allows spontaneity on the part of the actors and the photographer, and the length of the lens compresses the action into a flat, very designed plane.

He uses Kodachrome film for what he feels is the finest resolution and detail possible in 35mm. And detail is what Reid Miles's photographs are all about.

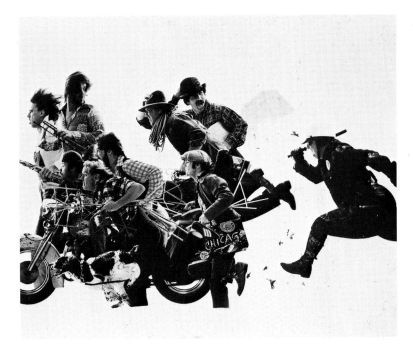

This shot was done as an album cover for the rock group Chicago and Columbia Records. The concept of the group being chased by a cop was carefully planned, but the actual shot had to be taken twice. The first time all the people were on the treadmill, and it bogged down under the weight. The second time I shot each individual character separately, and the photos were stripped together on a dye-transfer print. This allowed more control over each individual's action, and a much better final shot.

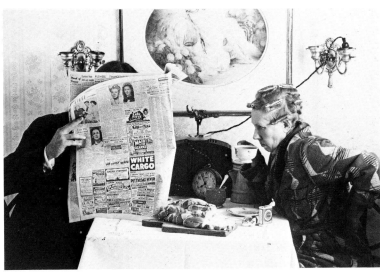

This is a straight shot, done as a food editorial for the "Home" magazine of the Los Angeles *Times* Sunday edition, to go with an article about coffee cake. The set was built in my studio and lit evenly overall with a key light to the left. The camera was a 35mm SLR and the film Kodachrome—in order to allow more freedom of movement for both me and the actors.

One of the keys to Arthur Beck's photographs is the light, how it works for the subject. In the three-dimensional world, light molds objects for our eyes. In photography it does the same, only more so, because photography conveys three-dimensional space in two dimensions.

Natural light comes from a single source, the sun. Arthur Beck also likes to use one source, a bank of strobes. It can be soft, or bright and harsh, but it comes from one direction—the direction that works for the subject, that makes it look the best. Each time it is different. But only one way is it absolutely right.

Sometimes Beck adds fill light to the shadow areas created by the main light, because film cannot reproduce the same large range of intensities that the human eye can. Light still works best from one primary direction, to mold and shape the object as it should be shown.

Beck usually uses an 8 × 10 Deardorf camera. The slides are impeccable for reproduction, and maybe Beck got used to thinking carefully about his pictures in his early "one shot per setup" days. The most important thing, though, is that on the camera's big ground-glass Beck can watch the subject, watch the light, and know that the picture he takes is the best one, the one that works.

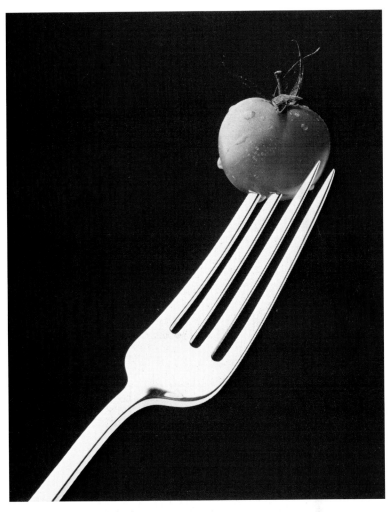

I used this fork for two shots. The first had a crouton on one of the tongs. The second, this one, had a cherry tomato. I was looking for a shot with one strong color contrasted against the high-key fork and deep black background. The tomato worked better than the crouton, and it certainly tasted better when I ate it.

The picture was taken on 8 × 10 Ektachrome E-3 film and lit with a single bright bank and no reflectors. The shot ran in a number of places, one of them a large American magazine.

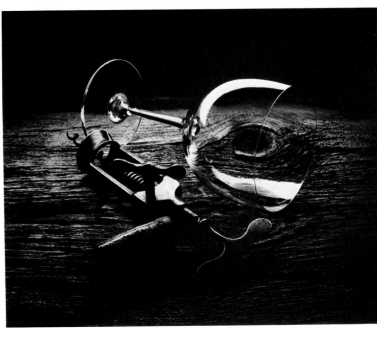

This shot was done for my own pleasure. It was done in about 15 minutes, and I like the melancholy feel it has. Like most of my work, it was lit by a single bank light and taken with an 8 × 10 Deardorf camera. The hardest part was getting the glass to look just right.

Almost all Gary Perweiler's still-life work is done with a large-format view camera—an 8 × 10 Sinar P, to be exact. The variable shifts and swings of a view camera are crucial to his type of still-life work. These controls offer the ability to have adequate depth of field while working with three-dimensional objects at close distances, but more importantly, they permit him to reproduce these three-dimensional objects as graphic shapes in two dimensions.

Perweiler also finds that the large ground-glass of this camera makes it much easier to study and compose the image than it would be with a smaller camera. And, of course, the large-format transparency results in a much clearer and crisper reproduction.

Perweiler almost always shoots 8 × 10 test Polaroids before exposing any transparency film. These test Polaroids give him an opportunity not only to check the lighting and exposure, but also to see how the composition and image work in two dimensions.

Most of Perweiler's images in this book were shot on Ektachrome 6115 film, as it was the only ASA 64 film available in the 8 × 10 format at the time.

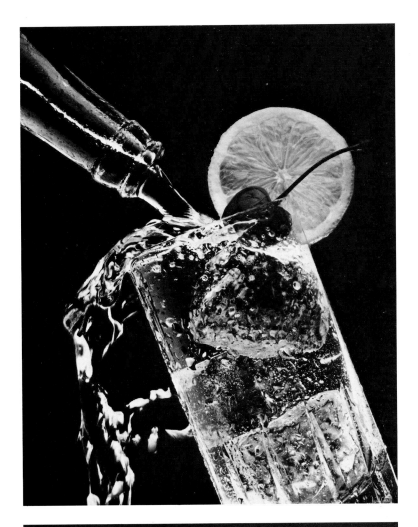

I did this pouring shot for my portfolio, in order to show potential clients that my graphic style could be applied to moving objects. The set was lighted by a single strobe on the right side, and a bright silver reflector was positioned on the left to fill in the shadows. The lens was a 165mm Super Angulon, and the exposure was f/64 at 1/60 sec. The hardest part was getting the right pour.

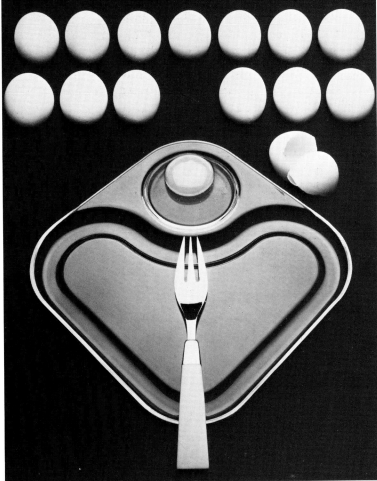

I also shot this photograph as a self-promotion piece, but later it was picked up and used as a poster by a graphics company. The picture was shot in my studio on an 8 × 10 Sinar. It was lit by one main strobe above and behind the eggs. The film was Ektachrome, ASA 64.

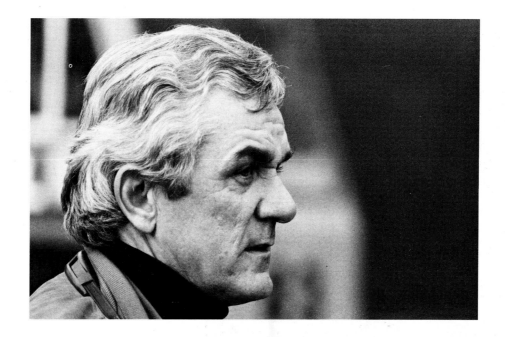

Anthony Edgeworth's portraits depend on the people in front of him, on the way they react to him, and what their reaction shows about their personality in the final photograph. This type of photography, requires a great deal of versatility and speed, the ability to catch a split-second expression, the ability to portray the person, and the personality, in his or her natural environment.

For this versatility, Anthony Edgeworth likes to use a 35mm Nikon camera, Kodachrome film, and the light already existing in the scene. The small-format camera and the consistent film allow him to concentrate on the person rather than the technical aspects of the photograph. The available light captures more of the ambience of the setting. Additional lights might make the photograph easier, but at the same time they would make it more artificial.

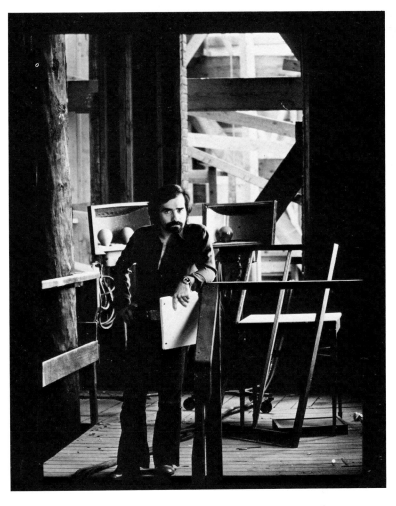

This portrait of film director Martin Scorsese was also shot for *Esquire* magazine. It is an environmental portrait, taken "on location" in a Hollywood film studio, showing not only the man, but also his working environment.

The studio was lit by the natural light present; no additional reflectors or light sources were added. The film was Kodachrome, and the camera a 35mm. The hardest part was getting Scorsese to keep still long enough for me to take the photograph.

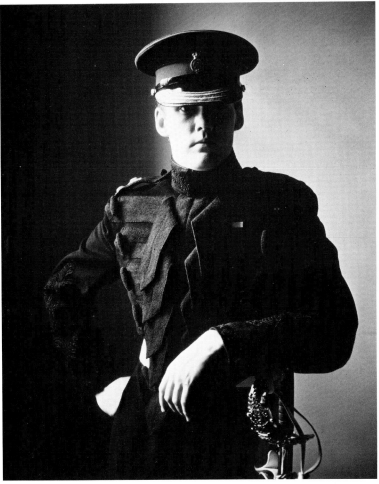

This photograph of a Guards officer in the Knights Bridge Barracks, London, was originally shot as part of an editorial piece for *Esquire* magazine, but it wasn't used by the magazine. It later became incorporated in my book, *The Guards*.

The room was lit by the rapidly failing light of late afternoon, the film was Kodachrome II, and the camera was a 35mm single-lens reflex.

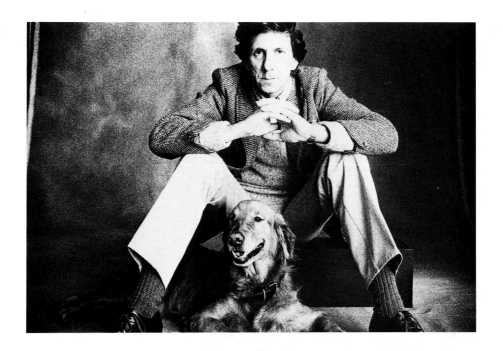

Almost all of Gordon Munro's beauty work is shot in the studio with electronic strobe lighting. He uses a number of different makes and formats of cameras (35mm, 120 type, and 8 × 10), but one of his favorites is the 2¼-inch square Hasselbald single-lens reflex. The slides it produces work very well for reproduction, but more importantly, the square format works with the shape of the human face. The slightly horizontal (or vertical) format of 35mm and 8 × 10 film just isn't as pure.

As far as lighting goes, Munro likes to do a number of different things—whatever works for the person in front of his lens. Sometimes he uses very soft and even light, to make the makeup the dominant aspect of the photograph. For other faces he uses spotlights to bring out the character and lines. It all depends on the face of the subject and the final photograph he is trying to achieve.

The effect of the final photograph is what really matters. A good beauty photographer must be aware not only of the technique to use for a shooting, but also of the people and how they look in the final picture. Munro figures out what the setting, lighting, and camera are—then he concentrates on the person and the expressions.

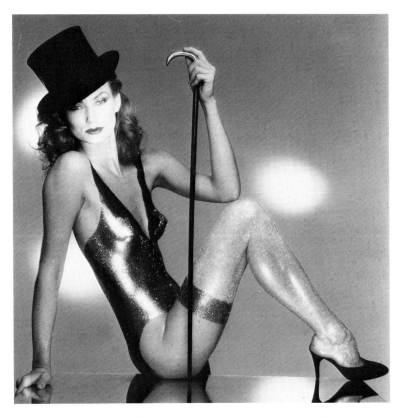

This photograph is part of a six-picture series I shot for myself. The hardest part was applying the glitter to the body paint. The picture was taken with a Hasselblad, Ektachrome Professional Film, and a Hasselblad Softar II lens attachment. The overall scene had numerous reflectors, but there was a key light on the face, and spots with gels were used for the background circles of light.

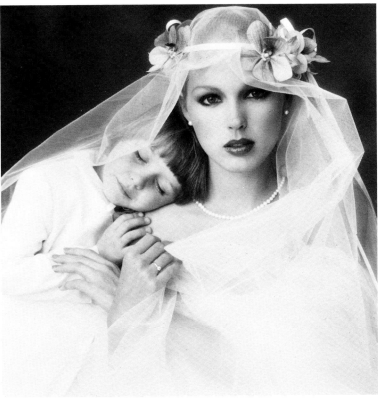

This photograph of a bride with a sleeping child was shot on assignment for Italian *Vogue*. It was used as the opener for a six-page spread of editorial pictures. While the concept for this spread was carefully planned, the actual picture only surfaced on the day of the shooting. The photograph was taken on Kodak Ektachrome Professional Film with a Hasselblad camera. The light came through an umbrella positioned above the camera.

171

Arthur Elgort likes to work on location—in the street, a friend's apartment, on the roof of a building—to get the natural feeling of a person wearing fashionable clothes in a real setting. These real settings call for the use of real light, the light that is there when the photographer and team arrive. To bring in additional strobes would be to transform the authentic setting into the artificiality of a studio.

He works with a number of different types and formats of cameras, picking the one that best suits the job. Often the camera is a 35mm single-lens reflex, but it might just as well be an antique 4×5-inch Speed Graphic, or even some more esoteric camera from his collection. But whatever the type of camera, it is only one element of a complex fashion photograph that also involves many other more subjective and intangible factors—the actions of the model, her feelings about the clothes, about the photographer, the relationship of the clothes to the background of the scene, and the instant when the photographer takes the picture.

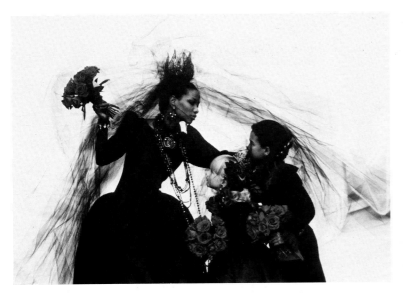

This photograph of model Mounia and children in a St. Laurent wedding dress was shot for an editorial article in French *Vogue*. It was taken on a terrace, very quickly, during collection time. The idea was planned, but the actual shot was the result of spontaneous reaction to the setting.

The camera was a 35mm, and the film was Ektachrome 200 EPD, because that is the easiest film to have processed quickly in Paris.

This shot of Susan Hess wearing clothes by Norma Kamali was taken in the studio with a Nikon camera and Kodachrome 25 film. The light was the available daylight coming through the window, but a reflector was used to bounce more of the light back against the rear wall. The photograph was used by English *Vogue*.

Working with a good model like Susan Hess, and easy clothes like those designed by Norma Kamali, makes it a pleasure to take fashion photographs. A good model just makes the job happen.

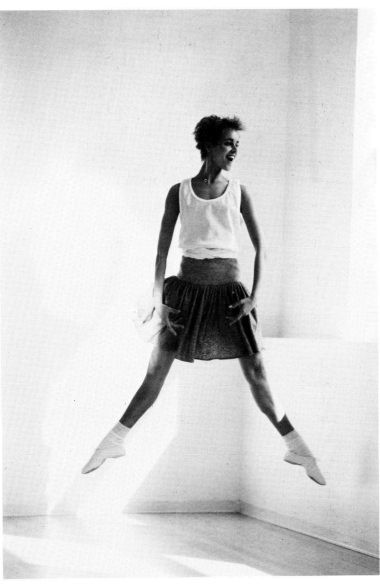

Burt Glinn likes to work with 35mm single-lens reflex cameras—Nikons, to be exact. Where possible, he uses Kodachrome film and the light already existing in the scene.

The 35mm camera may be a result of his early days as a photojournalist working for *Life* magazine. Indeed, annual report work bears many things in common with photojournalism. It demands versatility of subject matter, being able to photograph everything from a ball-bearing to a high-rise building, and the ability to travel to almost any location the client requests.

For these types of situations, small, light, yet versatile 35mm cameras are ideal.

This shot for Warner Communications is a perfect example of a shot that was hoped for, and occurred. Warners sponsors the New York Cosmos professional soccer team, and the exuberance of the crowd at one of the team's goals vividly illustrates the company's vitality. The photograph was taken with the existing lights in the stadium, a Nikon F camera, and Kodachrome film. The hardest part, and the luck, was waiting for the goal to happen.

This photograph of a Hamburg, Germany, shipyard was taken for a Xerox Corporation annual report. It is a combination of a "discovered" and a "controlled" photograph. The strong design of the ship's keel was there, but the two men were placed in exactly the right position. The lighting was the diffuse light of a rainy, cloudy day, the camera a 35mm SLR, and the film Kodachrome ASA 64.

Edited by Michael O'Connor and Judith E. Royer
Designed by Brian D. Mercer
Graphic Production by Ellen Greene
Text set in 12-point Memphis Light